How to Make an
OIL PAINTING

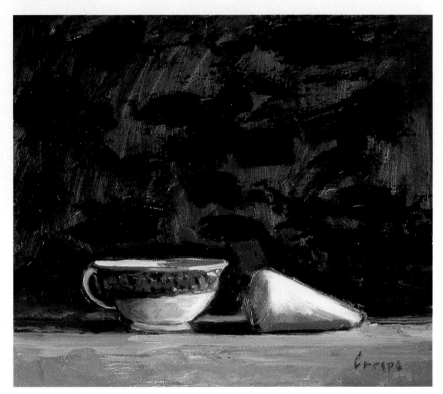

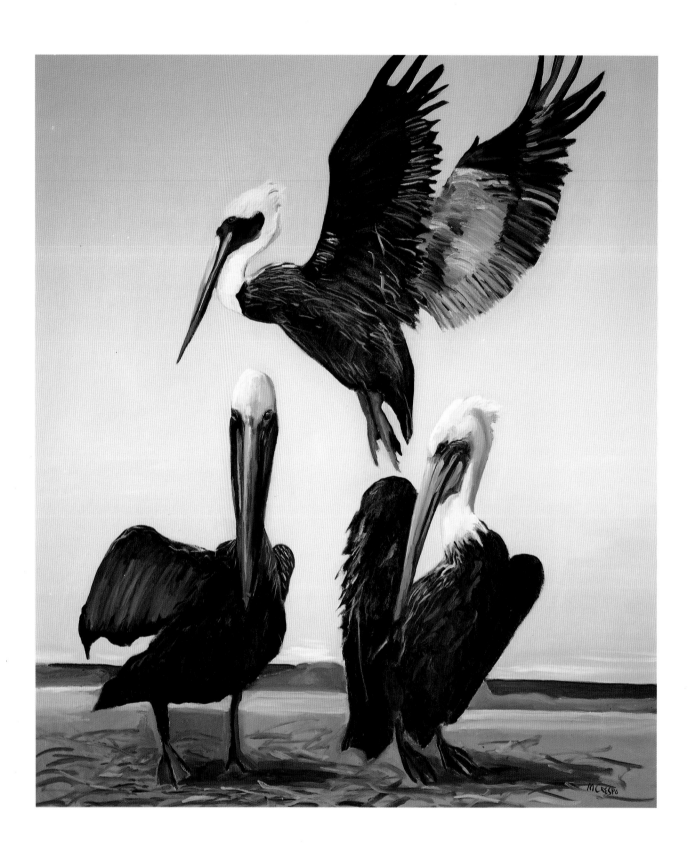

How to Make an
OIL PAINTING

Getting Acquainted with the Medium

Michael Crespo

Watson-Guptill Publications/New York

I thank all the artists and students who allowed me to fill my book with their wonderful paintings.

I thank Mary Suffudy for giving me free rein one more time.

I thank Janet Frick for her insightful editing and frequent, friendly communications.

I thank Jay Anning for his splendid design.

I thank Adrian Harris, Michael Book, Scott Woodward, and Duke Bardwell for their unflinching friendship and inspiration.

I thank my wife, Libby, and my children, Clare and Pablo, for their love and understanding—the space in which I live.

Art on first page:
MICHAEL CRESPO, **MY CUP AND NECE'S CONE**, *1983.*
Oil on canvas, 15" × 17" (38 cm × 43 cm).

Art across from title page:
MICHAEL CRESPO, **BROWN PELICANS**, *1984.*
Oil on canvas, 60" × 50" (152 cm × 127 cm).

First published in 1990 in the United States by Watson-Guptill Publications, a division of BPI Communications, Inc., 1515 Broadway, New York, N.Y. 10036

Library of Congress Cataloging-in-Publication Data

Crespo, Michael, 1947–
 How to make an oil painting / Michael Crespo.
 p. cm.
 Includes bibliographical references.
 ISBN 0-8230-0482-1
 1. Painting—Technique. I. Title.
 ND1500.C74 1990
 741.45—dc20 90-33796
 CIP

Distributed in the United Kingdom by Phaidon Press Ltd., Musterlin House, Jordan Hill Road, Oxford OX2 8DP.

Distributed in Europe, the Far East, Southeast and Central Asia, and South America by RotoVision S.A., 9 Route Suisse, CH-1295 Mies, Switzerland.

Manufactured in Singapore

First printing 1990

1 2 3 4 5 6 7 8 9 10 / 94 93 92 91 90

Edited by Janet Frick
Designed by Jay Anning
Graphic production by Ellen Greene
Text set in ITC Cheltenham Light

Contents

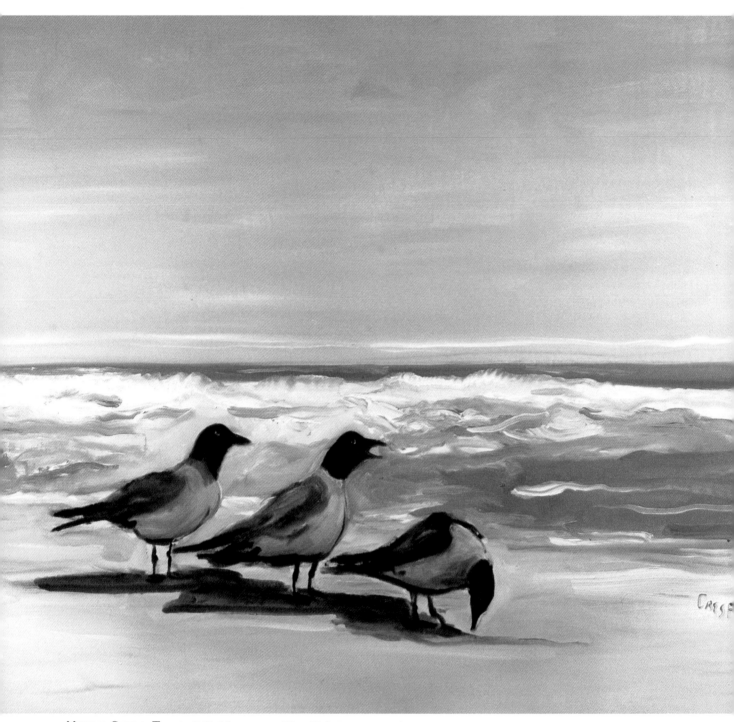

MICHAEL CRESPO, **TERNS**, *1984. Oil on canvas, 42″ × 48″ (107 cm × 122 cm).*

Introduction

Painting is a way to discover what we yearn for, whether that is truth, beauty, or reality. Painting is quiet, meditative work, comforting and productive. It is a way of converting troubles, fears, loves, and passions into something illuminating. It is a way of communicating with ourselves and others. It is enlightening.

Painting has an immense history filled with inspiring works by great artists. Embrace as many of these works as you can. Learn the artists' wondrous methods and theories, but remember that for each of us, painting still remains a virtually uncharted horizon on which we uncover and disclose our own special presence. When I paint, it is as if I am lost. I am aware of being lost, and understand just how lost I am, yet I am strangely comfortable. I feel secure, even euphoric.

The act of painting is simple and can be easily learned. This book is based on the beginning oil course I have taught at Louisiana State University for the past 19 years. It is my desire to provide you with the least complex, yet most thorough, route toward a valuable personal painting experience. You must provide the initiative, an open mind, and a willingness to look, feel, and record.

Follow the exercises in the sequence in which I have presented them. They are cumulative by design, and will provide you with an advancing progression of technique and theory. Refer often to the final section on pages 125–142, "You Must Remember This," which reinforces the most important points about each technique and makes them easy to remember with step-by-step visual demonstrations.

Do not begin this book with exaggerated expectations; let expectation grow with competence and time. Conversely, do not recognize failure. Your task is merely to address simple problems, and record your findings and impressions in paint. Have experiences rather than goals. At some point, somehow, you will feel that you are a painter.

Don't ever stop painting. And write to me if you're ever in doubt.

Materials

The smorgasbord of oil painting supplies is vast. Racks of paint, brushes, and prestretched canvases are now available even in the local drugstore. It's a good sign that the craft is flourishing. It also signals fierce competition in the supply business, so my first bit of advice is to spend some time shopping for the best prices as you collect the various supplies you'll need to complete the exercises in this book. Despite the competition for your business from various suppliers, art materials are expensive.

Usually the best prices appear to be found in the large mail-order catalogues. The main problems—unless you live near one of these establishments—are that you must wait three weeks to a month for shipment, and you usually have to pay for that shipment. Supplies, especially pigments, can be quite heavy. I suggest that you shop at your local art supply stores, seeking the best price for the best material. You'll find bargains from time to time, and (more importantly) you'll have a consultant who can answer your questions now and in the future, and be your spirit guide through the massive inventory of available art goods.

Brushes

One can never have too many brushes. Although you really need only a few, you won't be able to resist occasionally buying one of a new shape, size, or bristle. And as the years flow by, you'll end up with cans stuffed with well-worn veterans of countless paintings. I don't think I've ever thrown one away. Even the ancients, worn to the ferrule, can still carry out some task in painting.

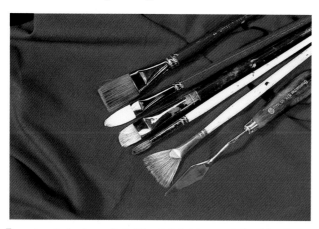

From top to bottom: flat, filbert, bright, round, fan blender, and palette knife.

Oil painting is best carried out with brushes of hog hair, sable, or synthetic sable. Unequivocally avoid the nylon-bristle brushes designated for acrylic painting. I haven't found a use for them yet, even with acrylics. Also avoid cheap bargain brushes. They do not hold a suitable shape and will shed their hairs as quickly as your cat. Better brushes will make better marks and service you for many years. Spend the little extra here.

Hog-bristle brushes are available in a multitude of sizes, and five basic shapes: flats, brights, rounds, filberts, and fan-shaped blenders. They have fairly stiff bristles and are the workhorses of painting. Sables, both natural and synthetic, are much softer and perform more specific tasks, such as glazing transparent colors and subtle modeling. They also come in many sizes and shapes. The synthetic sables are very popular now, and considerably less expensive than the natural sables. I recommend them highly.

The life span of a brush depends on how well you care for it. Clean your brushes after each painting session. Wipe the excess paint and turpentine from the bristles and clean them with dishwashing liquid, working lather into the bristles on the palm of your hand. Rinse them in cool water, shape them, and store them bristles up in a can or jar. When transporting brushes, never carry them in a position in which the hairs could be bent and smashed. Try a bamboo placemat as a carrier; just roll your brushes up in it for protection.

Paint

There are many fine brands of paint in the marketplace: Winsor & Newton, Grumbacher, Rembrandt, and Maimeri, to name a few. Most companies offer two grades: professional or artist's grade, and student grade. The less expensive student paints are diluted with more filler. This does not harm the tone or quality of the paint, just limits its tinting strength. Artist's grades are about three times stronger. Purchase what you can afford. You will have no problems down the road if you stay with a permanent palette, as suggested in the basic supply list. There are a number of fugitive colors that fade quickly, or cause cracking. You'll find lists of all colors and their behavior in any of the many books on artist's materials.

Oil paint is packaged in either tubes or jars. For convenience, I recommend the tubes, either studio size (1.25 ounces) or the larger, more economical size (5.07 ounces).

Supports

A support is the surface on which you paint, usually canvas or a panel of wood or Masonite. Canvas, either linen or cotton, is usually stretched over a wooden frame or mounted on wood or heavy cardboard. Popular sizes of prestretched canvas are readily available, as are canvas boards, which are much less expensive. Or you may choose to stretch your own, as illustrated in this chapter. Prestretched canvases and canvas boards already have a white ground of oil or acrylic gesso on them. If you decide to stretch your own, you can purchase unstretched canvas by the yard, either commercially prepared or raw. The raw canvas is easier to stretch, and afterward you can apply a ground of two coats of acrylic gesso. It will adhere best if you lightly sand between coats.

Untempered Masonite makes a permanent, inexpensive painting surface. It can be found at any lumberyard, and usually, for a small fee, someone there will cut a sheet into as many pieces and sizes as you wish. Before painting on Masonite, apply one coat of acrylic gesso to both sides to prevent the panel from warping, and an extra coat to the side you will paint. It's up to you whether to paint on the rough or smooth side.

Paper also makes a fine, permanent support, provided it is all rag content and primed. Tape and tack it to a board while applying two coats of acrylic gesso, so that it won't wrinkle when drying.

Miscellaneous

Palette. A palette is simply a flat, nonporous surface on which to lay out and mix your colors. Your personal working habits will determine what kind of palette suits you best. My only demand is that it be white so that you can accurately gauge your color mixing. I engage a number of different palettes for different activities. For my primary studio palette I use a large sheet of glass painted white on the back side, which remains stationary on my painting table. When I'm working on a very large painting and moving from one end to the other, or when I'm mixing a specific group of colors that I need to keep isolated (like the subtle flesh tones of a portrait), I use a wooden hand-held palette and a number of old china plates that work nicely. I sometimes use a pad of the disposable peel-off palettes of smooth paper. There are also airtight plastic boxes to accommodate these pads, which are especially good for going out to paint in the landscape.

Palette Knives. Palette knives not only make good tools for mixing paint on the palette, but also may serve as trowels for applying it to canvas. They are varied in shape and size. Purchase those that look and feel useful to you. Actual painting will dictate future needs.

Mediums. Artists seldom use oil pigment straight from the tube, but ease its handling and effect by adding one of many different mediums. Since oil pigments contain substantial amounts of oil, gum turpentine alone is an acceptable medium. I encourage my students to use Winsor & Newton Liquin, in addition to turpentine, because it speeds up the drying time of the oils. I suggest a small dab, about what you can pick up on the end of your brush, mixed with each puddle of color. When a painting is worked over in different sessions, the medium should be added in increasing amounts with each layer. This is in keeping with the "fat over lean" rule for permanence: In a painting with different layers, the oiliest should always be on top, the thin turpentine wash on the bottom.

When you make an indirect painting later in this book, I've asked that you mix your own medium of one-third gum turpentine, one-third stand oil, and one-third damar varnish. It's a standard medium and may be used throughout the lessons. Liquin may also be added to it to speed the drying time. Use about a teaspoon of Liquin per 4 ounces of medium.

Vine Charcoal and Drawing Pencil. These will be used to make initial drawings on canvas. Purchase the thin sticks of soft vine charcoal. Unlike compressed charcoal, vine is easily corrected by wiping. Charcoal drawings can also be blown from the surface, leaving a faint residue to guide your painting. Drawing pencils should be soft: for example, 2B, 4B, or 6B.

Jars, Cans, and Rags. You'll need at least three jars, cans, or other containers to hold turpentine, mediums, and dirty brushes. They should be glass or metal because turpentine will disintegrate many kinds of plastic and paper. An abundant supply of rags or paper towels should be on hand for clean-up.

They are also useful for applying paint to and removing it from your canvas.

Easel and Table. I suggest you avoid the small table easels and instead select a standing easel—either a folding easel, which is excellent for storing away and toting into the landscape, or one of the more stable and more expensive studio easels. There is also the French landscape easel, which is a folding paint box, palette, and easel all in one. You'll also need a small table for your palette, brushes, and mediums. One or two TV trays work well and are easy to store.

Sketchbook. Purchase a small sketchbook for use as a journal. In it make thumbnail sketches of your subject before each painting. Record in words and images anything pertinent to your work as a painter—a favorite color mixture, future subject matter, a line from a poem, the latest perfect medium. Over the years a well-kept personal journal will surpass any book ever written on oil painting.

Caution

Many of the various mediums and pigments are toxic. Care should be taken in their use. Be certain to read any warning labels on the materials before working with them. I strongly recommend wearing examination gloves while painting. They are inexpensive, comfortable, and available at any drugstore or science supply house.

Basic Supplies

Here is a list of the basic supplies you will need. I've tried to keep it to a minimum, and I suggest that you supplement it over a period of time. Eventually you will have gathered an ample cache of materials, and perhaps be a little less aware of the cash outlay.

Brushes
#2 flat hog-bristle
#4 flat hog-bristle
#6 flat hog-bristle
#3 hog-bristle fan blender
Small round synthetic sable for detail work
1-inch flat synthetic sable

Oil Colors
I recommend studio size tubes (1.25 oz.) of all colors except titanium white. Because you'll be using a lot of that, buy a large tube (5.07 oz.) of it. These are the colors you'll need:

Grumbacher red (Cadmium red medium may be substituted, but I find the Grumbacher to be the truest.)
Alizarin crimson
Ultramarine blue
Phthalocyanine blue
Cadmium yellow medium
Hansa yellow or lemon yellow
Cadmium orange
Phthalocyanine green
Burnt sienna
Raw umber
Yellow ochre
Ivory black
Payne's gray
Titanium white

Miscellaneous
Disposable paper palette pad (large size, glossy surface)
Palette knife
Vine charcoal and drawing pencil
Gum turpentine
Winsor & Newton Liquin medium
Damar varnish (small bottle)
Stand oil (small bottle)
Jars and rags
Sketchbook
Examination gloves

Supports. Read over each exercise and determine which support and size you wish to paint on. Choose from canvas boards, prestretched or self-stretched canvas, primed Masonite, or primed paper.

Color and Value Mixing

I can well recall my first painting. I had never had even an inkling of desire to paint, but one day some inexplicable force hurried me off to a local art supply store to purchase the trappings of my suspicious impulse. In my naïveté and student poverty, I came away with only one brush, one tube each of white, burnt sienna, and ultramarine blue; a small jar of turpentine; and a canvas board. Back in my room, with a chair for an easel, an old record jacket for a palette, and dreams of grandeur, I painted an odd geometric seascape with a very weird egg-shaped man in a boat. Immediately upon completion I beckoned an art student acquaintance to come and view my proud outpour. I was shot down fast as he laughed aloud at my neophyte color handling: I had used the colors as they came from the tubes. I made no changes in their value and dared not even consider mixing any of my treasured hues together! I crumbled into the corner, but paid heed to my rude instructor and feverishly repainted with primitive craft, enthusiastically uncovering new possibilities of color and light. Unfortunately my efforts produced a less than mediocre work, but my spirit was not bridled. I enrolled in a class and went on painting with a much expanded palette and a wonder at the infinite products of color mixing.

Although now I find students much more sophisticated than I was, I am comforted that many of them begin their first painting with the same curious reluctance to blend any of their colors or make any value distinctions. I intend for you to immediately start hurdling these barriers in your first painting efforts.

Exercise: A Value Scale

Squeeze black and white onto your palette and have on hand a piece of heavy drawing paper or a scrap of mat board to serve as a painting surface. On your palette, make an ample puddle of black, thinning it with a little turpentine. Load one of your brushes and make a swatch of the black near one edge of the paper. With your palette knife mix a little white into the black puddle to make a gray. Don't use too much white, because I want you to make six more graduated grays before arriving at pure white. Once

you've finished, go back in and make adjustments by mixing either black or white into the swatches if needed. The intervals between these values should be as similar as possible. Tack this to your studio wall. It will serve well as a chart for mapping out value systems in the paintings lying ahead, or just as a reminder of the vast potential of value as a harbinger of light in your work.

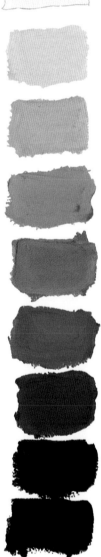

This value scale shows a gradual nine-phase transition from white to black.

Exercise: A Color Wheel

Smearing blue and yellow crayons together to make green was probably your first exposure to the color wheel, which I will refer to from time to time through these pages, because it provides a sound basis for color theorizing. It is composed of two basic triads: the primary triad, consisting of red, yellow, and blue; and the secondary triad, consisting of green (blue plus yellow), orange (red plus yellow), and violet (red plus blue). Let's expand it further to the tertiary colors: red-violet, blue-green, yellow-orange, and so on. Colors that are opposite each other on the wheel, such as red and green, are known as complementary colors. Colors that are adjacent, such as blue and green, are called analogous colors.

When red, blue, and yellow are mixed together in equal portions, the result is the primary gray. Mixing complementary colors such as blue and orange produces what some call complementary grays also; however, such grays are still based on the primary gray. For example, mixing yellow and violet is the same as mixing yellow and red and blue, since violet is a combination of red and blue.

This basic color theory is wonderfully expanded when we apply it to the various pigments we employ. "Blue" could refer to ultramarine, cobalt, Prussian, or cerulean blue, to name just a few. All have different properties and effects, so that you have an almost infinite array of choices in your paintings.

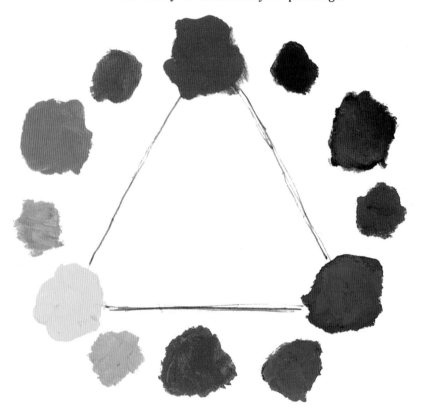

For this color wheel, I mixed combinations of the three primaries, (Grumbacher red, cadmium yellow, and ultramarine blue) to make the secondary triad (orange, green, and violet). I did not mix them in equal proportions, but had to adjust my mixtures to compensate for the tinting strengths of the different colors. By mixing primaries with secondaries, I expanded the wheel further to the six tertiary colors: red-orange, yellow-orange, yellow-green, blue-green, blue-violet, and red-violet.

Exercise: A Study in Primary Grays

For this painting you will mix and utilize two primary grays as your color system. First set up a still life of one or two objects on a piece of drapery. Try to choose objects of simple geometry, since complex forms may tend to frustrate you at this early stage. Illuminate your setup with a strong spotlight from either left or right. It is imperative that you have dramatic lighting to work from in this painting.

Lightly sketch your subject with vine charcoal directly on the canvas. Remember that you can easily correct your drawing by rubbing out with a rag or your fingers. Proceed until you are pleased with your drawing, remembering that it is just for basic proportions and will be reconsidered as you paint. Remove any excess charcoal by blowing it off or by lightly dusting with a rag.

Do you feel a tinge of excitement coming on? Some of you are on the threshold of your first painting. With your palette knife mix together Grumbacher red, ultramarine blue, and cadmium

yellow in as equal amounts as possible. The goal here is to arrive at the most neutral gray possible. The mixture may be too dark to judge, so smear a tiny bit of white at its edge to see what you've got. Keep adjusting until you have a gray that doesn't speak too loudly of any one of its constituents. If it's too red you'll need to add a little blue and yellow, and so on. That color wheel on your wall will come in handy now.

Don't worry if complete neutrality evades you. I especially do not want you to spend too much time mixing back and forth until great wasted mounds of paint appear on your palette. Providing that there are no intense hues present, a little hint of color can be a welcome tool.

Mix another puddle of dark gray using your other primaries: alizarin crimson, phthalocyanine blue, and lemon yellow. These primary hues are not only visibly different from the others, but also more transparent. They will produce a slightly different gray for you to work with, both in hue and in consistency. Keep your two grays well apart on your palette because you'll need some space around them as you proceed.

Now look at your still life and try to discern the major shapes of values: light, dark, and middle. Pay little attention to the color; concentrate on the value. (For example, pale yellow and pale pink would be about the same value; so would dark red and dark green.) Squinting your eyes a bit out of focus will help diminish some of the subtleties. These shapes you're seeing are the essence of value in your setup and a major structure on which to build your painting. Returning to your palette, mix puddles of the values you are perceiving as best you can by adding white, or black if needed, to your two primary grays. You may use them randomly because color is not an issue here. Don't get carried away and mix too many, just the obvious levels of value that appear via your squinted eyes.

Load an appropriate brush with your darkest value—if needed, a dip of the brush in turpentine will render the paint more manageable—and proceed to record the corresponding dark shapes of your subject on to your canvas. Paint your other shapes of value, using your initial sketch as a guide, but by all means ignore it should you find a way to improve upon it with the paint. Move around the canvas; don't get hung up on one object. Remember that you are not painting objects, but shapes of light and dark. Ultimately, they will form into credible objects in credible space. Toward the end, you may

wish to adjust some of the shapes or perhaps embellish your painting with some of the details that animate your still life. Just be careful not to get too fussy. It's sometimes so easy to destroy the simplicity of vision with a mess of insignificant detail. Make this painting "alla prima," or in one session, and be done with it.

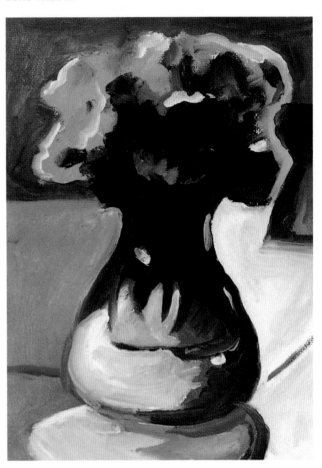

MICHAEL CRESPO, **VASE OF PANSIES,** *1989. Oil on canvas board, 12" × 9" (30 cm × 23 cm).*

The complexity of a bouquet of flowers provided me with great incentive for simplifying form in my attempt at solving the problem I've posed you. I relied heavily on squinted eyes to subdue the exquisite, detailed clutter of the flower petals and record only the simple shades of light and dark, best exemplified by the elementary geometry of the background.

I was careful to find an adequate expanse of values to chart the transition from the dense, dark central shape to the pure whites that are adjacent. The small staccato lights that float across the surface were the last marks applied, and are essential punctuations of scale and value. I let the background run a little warm to contrast with the other, slightly cooler values.

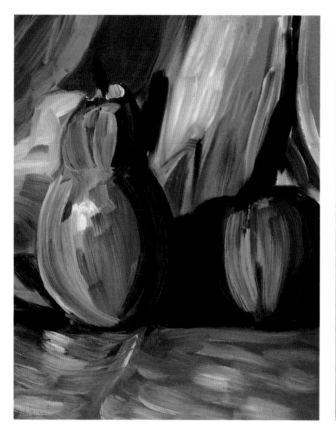

DENISE PLAUCHÉ, *student work. Oil on canvas, 14" × 11" (36 cm × 28 cm).*

MICHAUX WHITE, *student work. Oil on canvas, 10" × 8" (25 cm × 20 cm).*

Denise Plauché activated the surface of her painting with rigorous brushwork. The wispy texture of the strokes was achieved by painting the whites last, directly into wet, darker values. This mingling yielded soft edges and produced a version of impressionist light, as witnessed in the foreground at the bottom of the painting.

Denise breathed a slight color contrast into her two primary grays: One leans toward green and the other is slightly reddish. The emphatic band of dark values from which the objects emerge provides an effective contrast to the more indefinite passages of brushwork.

Michaux White rendered her objects into a shimmering mass with thick paint build-up and frenzied markings. She chose a difficult vantage point from which to paint: A fast moving diagonal line of objects can sometimes be unmanageable, directing the eye too quickly across the space. However, Michaux thoughtfully organized her values and painted a very dramatic focal point of contrasting darks and lights at the dead center of her format. The diagonal movement is further stabilized by the dark vertical shaft at the top, somber and centered, in contrast to its bent counterpart on the right.

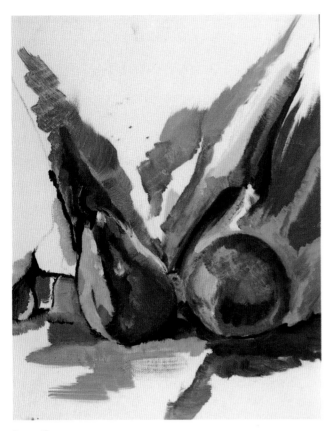

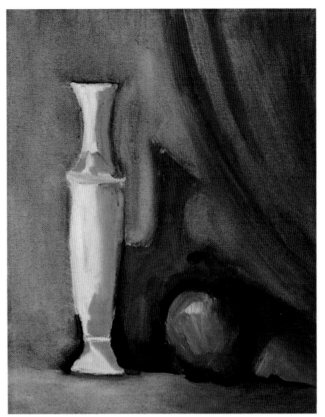

JULIE CASEMORE, *student work. Oil on canvas board, 14″ × 10″ (36 cm × 25 cm).*

DIXON SMITH, *student work. Oil on canvas, 12″ × 9″ (30 cm × 23 cm).*

Julie Casemore used a subtle range of middle values to construct a space of clearly defined planes. She employed a few well-placed linear darks as accents, and audaciously left a sizable tract of canvas unpainted. I applauded her quitting at this point, because the white of the canvas functions as a dazzling field in contrast to the more leaden movements of the grays so close together in value. She also allowed the white to penetrate into the painted portion, successfully entwining the two different surfaces.

Note the dramatic V movement formed by the drapery, its point striking a wedge between the pear and orange. Here Julie enhanced a dynamic compositional event.

Dixon Smith used warm and rosy grays as a backdrop for the slender white vase, whose volume she rendered in economical strokes of a single value. Its partner, the apple, was worked over more in subtle yet complex value changes. The apple's small white highlight not only sets off its volume, but also creates a fine-scale counterpoint to the relatively massive white area of the vase. I am intrigued by the path of the darkest dark as it worms its way in from the right edge of the canvas, surrounds the apple, and leaps over to attach to the bottom of the vase. It works equally well as an event in its own right and as a device to anchor the objects to the space.

The Temperature of Color

Color floods our eyes at every moment. Even in a room of darkness, we cannot escape the wash of obscure blues, greens, and purples that bestow on us faint recognitions of vague nocturnal forms.

Color preys on our senses both directly and symbolically. Red may muster excitement and happiness, yet symbolize violent death. Blue can signal the optimism of a lucid sky, or the doldrums of depression. (Compare the two songs "Blue Skies" and "Blue Monday"!)

The arena of color is complex, and one of our challenges as painters is to harness the intricacies into simple, seemingly uncontrived structures. The power of color can be used deliberately to beat the viewer over the head . . . or to perform a more unassuming seduction, subtly disclosing the intentions and mysteries of the artist's vision, both painful and delightful. One of my tasks throughout this book is to provide you with some broad, umbrellalike color strategies under which you can comfortably locate yourself to seek and find those colors that best interpret and illuminate the world that you see and feel. In the painting you are about to begin, you'll work with the hot and cold of color.

Scan your color wheel and decide which colors appear hot and which appear cool. Yellow seems the hottest color to me, with blue moving toward blue-green, the coolest. I find green and violet to be the transitional areas for temperature. Green cools off as it moves toward blue and warms toward yellow. Likewise, violet does the same as it approaches blue and red respectively. You may disagree with some of this, and you would be right, because the greatest lesson of color is that it is relative both to itself and to those using it. A particular orange might appear much more sizzling in a field of blue than it would in a field of yellow. And you may feel that red is hotter than yellow. But I think we can agree about a general sense of warm and cool.

Exercise: Two-Session Exploration in Temperature

Set up a still life in which all the components are warm in color. As in the first painting, light it dramatically to provide strong value changes. Lay out a full palette of color. This time use your brush instead of your palette knife to dip into your paints and mix all your color. Eventually you'll fall into your own painting habits; until then, experience as much as you can.

Make a charcoal sketch on your canvas and begin laying in your painting. However, despite the warm colors of your still life, work only with colors you have designated as cool. You've got the forms and values to look at, you'll just have to translate them into different colors. It's a good exercise for the painting muscle in your brain. Pay attention to your value structure, because it's important to have a good range from light to dark. Explore as vast an array of cool colors as you can find. Don't hold back—make many color changes. Paint until you're content that your work is finished. Then put it away and let it dry. Keep your setup because you'll be working from it again.

In a day or so your painting should be dry enough so that painting over it will not bring up any of the existing paint. Return to your still life and commence to paint again, this time working with the warm colors of your palette, more correspondent to the colors you're perceiving in the setup. You may either rework the entire painting in warm color, or just scumble some warm highlights across the surface. Scumbling, by the way, is the casual application of a contrasting (often lighter) hue over another already dry. As you proceed, you'll notice how the warmer colors literally jump from the cooler environment you're applying them to. Spatially, warm colors project, while the cools recede. This should make more depth in your painting. The degree to which you wish to cover your cool underpainting is up to you, but in the end some evidence of it should remain, so that temperature contrasts are visible to make for some exciting color stimulation. Hopefully this will atone for your probable reluctance at having to repaint a finished painting. In the learning process you shouldn't become overly attached to your work, and besides, a major gain will be the exploration of a broad spectrum of your palette.

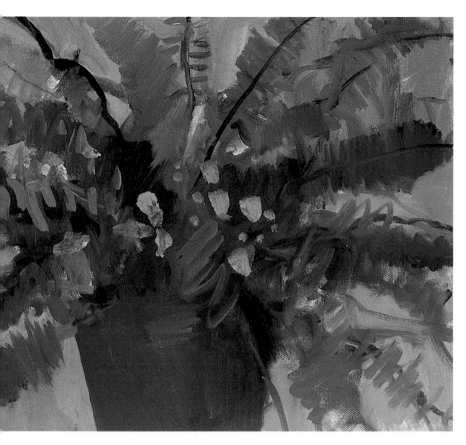

In this first stage painting of a fern that resides in my studio, I utilized the blue to blue-violet to red portion of my palette. I spanned a full range of values and tried to keep the brush moving in the lively rhythms I detected in the plant. It was unnecessary to get caught up in too much detail, because I had already planned to cover most of this phase in the next session. Note that the pinkish color, although still on the cool side of red, seems quite warm in its cooler surroundings.

During this second stage, I worked over the cool painting with warm yellow-greens, greens, and gray-greens, and finished it off with some pure reds and yellows as focal points. Most of the cool underpainting was covered, but as you can see, I let some peek through from within the fronds to add greater depth to the plant and make use of some temperature contrasts. There's also a bit of a chill in the pot.

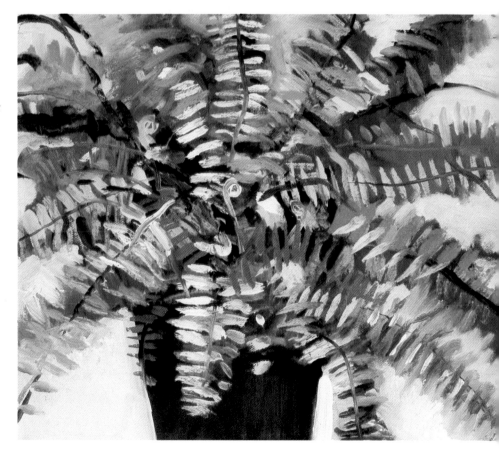

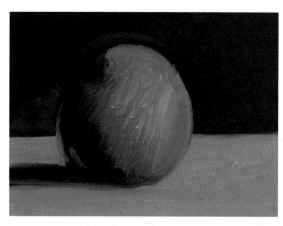

I developed this underpainting a little more than the one of the fern, since I planned to leave more of it exposed in the finished work. To establish some compositional dominance for the fruit, I grayed the background colors. The little flecks of white are simply unpainted canvas, which worked well as highlights.

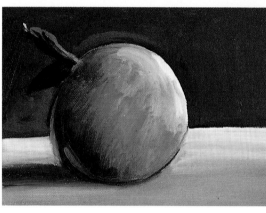

At this stage I made a short day of it by just scumbling some yellow and orange on one side of the fruit and the table plane. The cool underpainting showing through exaggerates the heat of the light and cool of the shadows, lending a pleasing sense of drama to the ordinary citrus sphere.

JUANITA CACIOPPO, *student work. Oil on canvas, 14" × 18" (36 cm × 46 cm).*

Juanita Cacioppo rendered her bluntly stated still life in blazing colors. The cooler patches of blue also figure prominently, making the hot colors appear even hotter by comparison. The pale yellow background does not stop as a backdrop, but invokes an eerie deep space, like the sky over a burning desert.

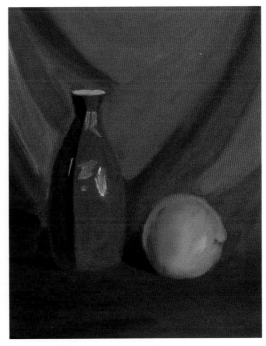

GLENDA SPIKES, *student work. Oil on canvas, 10″ × 8″ (25 cm × 20 cm).*

Glenda Spikes made each element in her painting successively cooler: lemon, red drapery, vase, and finally ground plane. A bit of the underpainting darkens the shadows.

MICHAEL GUIDRY, *student work. Oil on canvas, 12″ × 9″ (30 cm × 23 cm).*

Although Michael Guidry covered his first layer almost completely, these warm colors still show the effects of the cool ones lurking below— especially in the shadows.

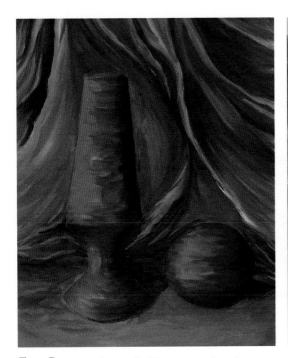

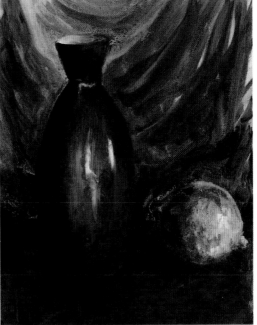

TODD PALISI, *student work. Oil on canvas board, 12″ × 9″ (30 cm × 23 cm).*

Todd Palisi made much use of his cool underpainting, mostly to highlight the peaks of forms with acidic warm colors. The yellow-green ground plane puckers your cheeks!

DOTTI BERRY, *student work. Oil on canvas board, 12″ × 9″ (30 cm × 23 cm).*

Dotti Berry painted both layers with thin, oily pigment. She intensified the lighting by letting it ignore the table, strike the objects harshly, and wander into the drapery.

JOHN OPIE, **PEP BOYS,** *1989. Oil on canvas, 25" × 42" (63 cm × 107 cm).*

In the dominant cool color of night, John Opie ignited some strongly contrasting heat to stage this painting of a man atop an auto supply store. John describes his use of the rooftop sculpture as a way of using gigantic figures alongside mortal-size people—a theme that currently occupies him.

Note the asymmetrical balance of his composition. At the right is the imposing, dramatically lit sculpture, hardly an equal match for the little human silhouette. But the intense isolation of the flashlight's small circular glow and the red remnants of letters have powerful visual effect and do balance out the massive threesome, cigar and all.

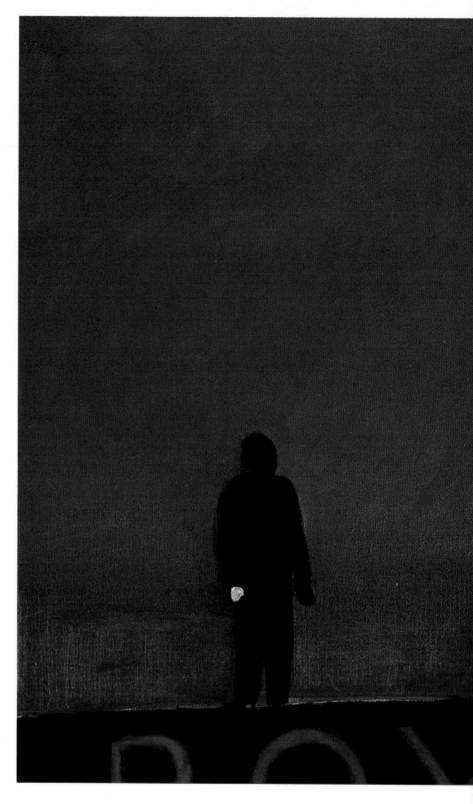

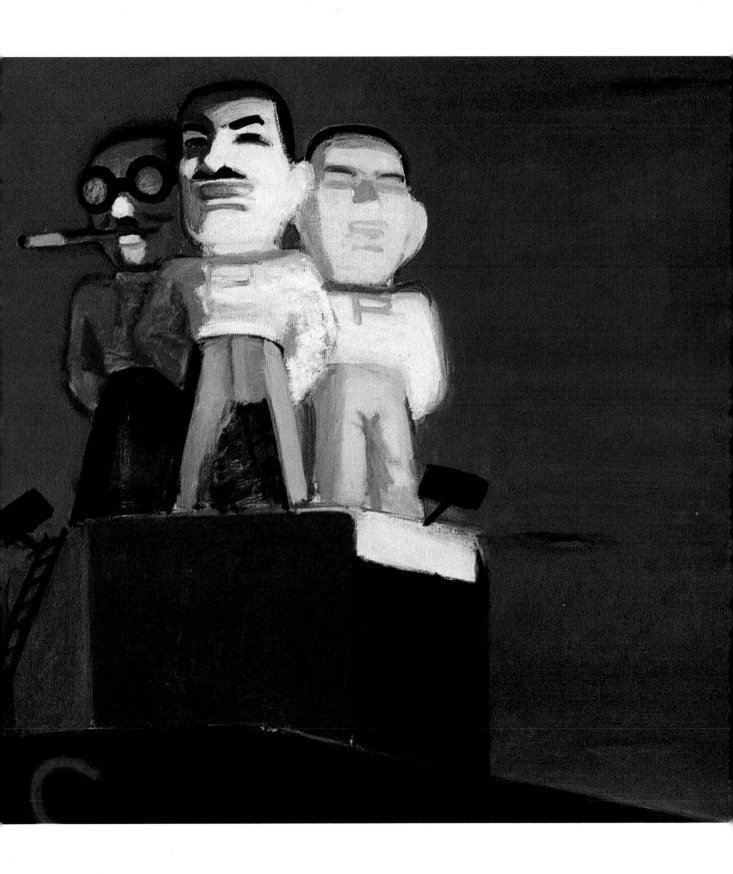

Shape

We have always been intrigued by the thought of adding a fourth dimension to the three that compose our physical reality: height, width, and depth. Likewise, when we subtract the dimension of depth, we are released into another equally astonishing world, where flatness reigns, reducing everything to shapes on a surface. And while we can orchestrate lines, values, and colors into stunning illusions of our three-dimensional surroundings, remember that illusions are just that, illusions. The realities of the two-dimensional arena in which we work lie in how those same lines, values, and colors move across that unflinching flatness, sending their signals to the eye, detached from subject matter.

You are about to explore some of the mysteries of two-dimensionalism by carefully observing nature and translating its shapes into the domain of your painting. Consider the missing depth not a restraint, but a liberation.

When a single line is drawn across the canvas, shapes are made, or at least implied. A contrast of color, value, or texture with its surroundings also produces a shape. Shapes are either geometric or amorphous. Triangles, squares, circles, rectangles, and ellipses are but a few in the geometric category. In contrast, amorphous shapes are all those lyrical, free-flowing, organic configurations that cannot be identified by name.

Those shapes that are employed as planned compositional elements are known as positive shapes, whether they are recognizable (a tree, a cup, a person) or nonrepresentational. Negative shapes are formed by the spaces between positive shapes or between positive shapes and the edge of the canvas. These two shape types are also known as yang/yin, figure/field, and figure/ground. The term "negative" is not meant to be derogatory here. On the flat, two-dimensional painting surface, positive and negative shapes share equal status. Negative shapes are more often overlooked by beginning painters, however.

Exercise: Composing with Flat Shapes

Scour your possessions for as many objects as you can muster, at least 15. Set them randomly on a table in the middle of your work space, in order to bring the surroundings into the composition. The more cluttered and complicated this setup is, the better.

Find an area in the still life that you think contains the most interesting shapes. As you look, try to imagine that the three-dimensional space before you has been transformed into a flat plane of many shapes. (With a little coaxing from your mind, your eyes will follow.) Dwell on a negative shape, and with any color of your choice loaded on a brush, paint that shape near the center of your canvas. Do not outline first, but respond directly and quickly. Find another negative shape and do the same. You may use any and as many colors as you wish. They may correspond to what you're observing, or be totally illogical. Don't worry about it; eventually your painting or your instincts will suggest what to do.

Concern yourself with finding and painting those negative shapes until you've covered much of your surface. Positive shapes will be appearing in the gaps. At this time, start working color into them. Pay attention to the edges of your shapes. Make some sharp and crisp, and smear others with your brush or fingers into subtle transitions. Establish a strong value range from light to dark. Go back into some of your colors, actually mixing new colors or adjusting values directly on the canvas. Vary the sizes of your shapes from the tiny to the relatively large.

When your painting has reached some conclusion, study it for a while and observe that although you've made a flat patchwork of shapes, you've also created some very remarkable spatial illusions. Shapes of colors in varying hues, temperatures, intensities, values, and sizes are not content to sit on that flat surface, but appear either to recede into the surface or to project out from it, creating a sense of many different levels of space.

A triangle is one kind of geometric shape. Any shape that has a name, or that you studied in high school geometry class, can be used in painting.

Here is an example of an amorphous shape. A shape need not have a name or represent anything in the physical world; it can arise from your imagination and be completely unique.

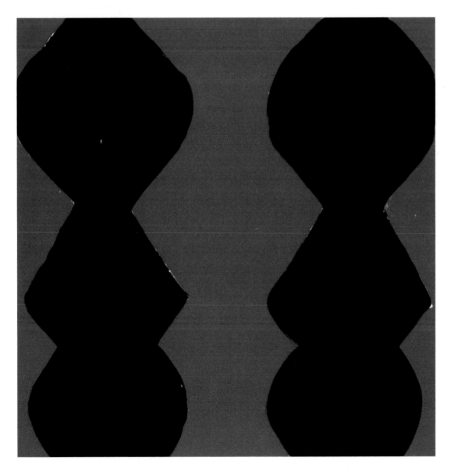

In this illustration, the positive black shapes form very distinct negative red shapes out of a red field. The central red negative shape is every bit as imposing as the black shapes.

LAURA GERNON, *student work. Oil on canvas board, 12" × 16" (30 cm × 41 cm).*

Laura Gernon created very credible space by paying close attention to the light on her still life. There are a few forms that are vaguely recognizable, but it is the bright, warm highlights that truly promote depth of space as they sit among the majority of cool, close-valued, darker shapes. We move about the space hopping from one bright patch to another as if they were stones in a brook.

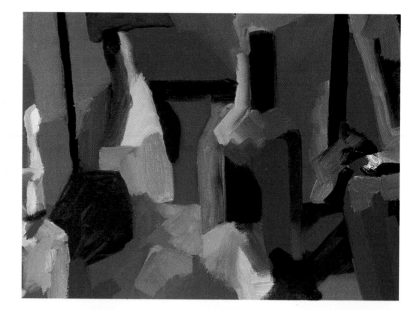

GLENDA SPIKES, *student work. Oil on canvas, 9" × 12" (23 cm × 30 cm).*

Glenda Spikes found a more regimented pattern of geometric shapes in her composition. Vertical and horizontal rectangles rule, imparting a rigid, perpendicular sense of organization, despite the fanciful arabesque shapes that cluster in the foreground. Note how the lighter shapes mass together, causing the darker ones to follow suit.

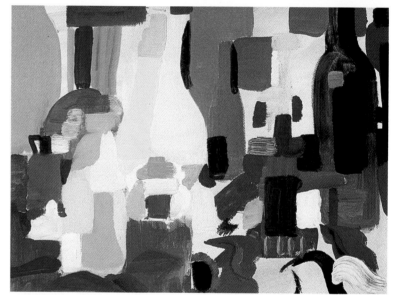

DONNA MARTIN, *student work. Oil on canvas board, 12" × 16" (30 cm × 41 cm).*

The bottle shapes that appear in all quadrants of Donna Martin's composition counterbalance the frenzy of small irregular figurations that dart about amidst them. The largest shapes are across the bottom of the painting, making the foreground seem very close to the viewer, with the smaller shapes appearing to drop back in the distance.

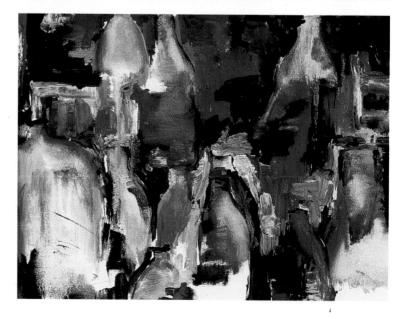

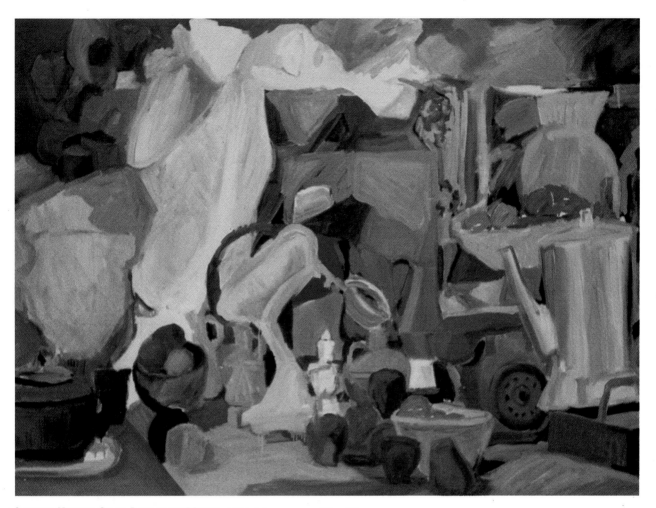

Lʏɴᴇᴛᴛᴇ Kɴɪɢʜᴛ, **Sᴛɪʟʟ Lɪғᴇ ᴡɪᴛʜ Mɪxᴇʀ,** *1987. Oil on canvas, 45" × 60" (114 cm × 152 cm).*

Lynette Knight quilted a profusion of shapes from a wonderfully overloaded setup. The mixer—along with the little blue crescent that clings fast—is a very commanding central focus around which the cornucopia of shapes revolves.

The focused shapes of the foreground dissipate into the vaguer masses at the top of the painting. This illustrates a principle of atmospheric perspective, which enhances the illusion of depth. We'll explore it more fully later.

MIRIAM SILVEY, *student work. Oil on canvas, 12" × 16" (30 cm × 41 cm).*

In Miriam Silvey's painting based on a segment of coral, the network of sparingly modeled yellow shapes brings to life the equally graceful dark, textured shapes. Miriam embellished them by cutting through wet dark paint with the sharp handle of a brush to expose lines of lighter dried color.

ANITA MITAL, *student work. Oil on canvas board, 16" × 12" (41 cm × 30 cm).*

Anita Mital applied color perspective to deepen the illusion of space in her field of shapes. The large yellow foreground shape becomes a smaller doorlike shape that definitely appears to be farther back into the space. The blue shapes get smaller as they snake their way through the painting from the lower left to the middle right and out through the yellow door.

JULIE CASEMORE, *student work. Oil on canvas board, 16" × 12" (41 cm × 30 cm).*

Once Julie Casemore laid out the basic shapes of her composition, she went about assigning them different roles to play. There are black shapes, shapes of unpainted canvas, shapes modeled into volumes, shapes of brushed textures, shapes scraped in with a palette knife, and shapes decorated with pattern. A central blast of red and its smaller satellites around the painting hold everything together.

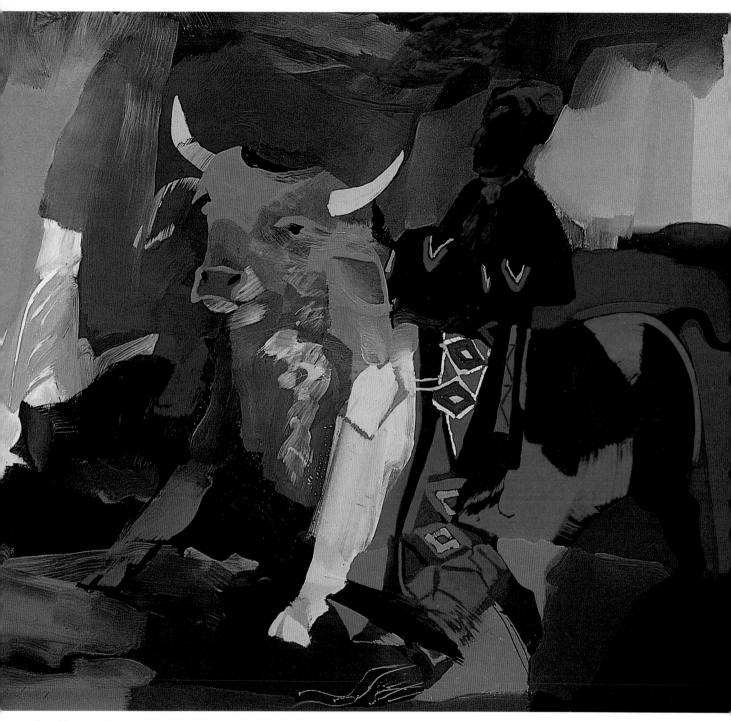

Ann Harding, **Investiture,** *1988. Oil on canvas, 56" × 64" (142 cm × 163 cm).*

Ann Harding constructed her mythical image of bull and man with wet, oily shapes of scintillating color. Ann well understands the dual roles of shapes, for hers not only divulge uncanny effigies of her subjects, but they stand equally well alone, as lyrical, abstract components. Ann's intense passages of color are magnified even more by their smoky, muted surroundings.

Thin Paint

If you've ever painted in watercolor, you are no doubt familiar with the stunning delicacy of thin and watery washes gushing across the white surface of paper, finally settling in, staining, but never completely masking the whiteness of the ground. It is an airy affair, especially when compared to the more heavy-bodied, opaque oils. But oil paint is a very pliable medium and can be approached similarly to watercolor, with flowing diluted colors and the textured white of canvas playing major roles in the finished painting.

In the most common process of constructing an oil painting, the initial drawing is made on the canvas, and then colors heavily diluted with turpentine (known as turp washes) are applied. These washes can be physically manipulated more easily than thicker, more decisive paint, and the white of the canvas can be quickly reexposed with the swipe of a rag. Highlights can be added this way without using white paint. Charcoal and pencil corrections can also be redrawn into the washes. This procedure is referred to as laying in a painting. Normally a finished painting is not being sought during this stage. It is an exploratory period of trying out colors, values, and placements that will form the matrix on which the thicker, more refined, more opaque colors will be applied, establishing the denser surface of a finished work. But this time you will make this interim stage the entire process, finishing with a painting in which form and color are resolved with the impulsive paint handling of laying in.

Exercise: Painting with Washes

Set up a still life of three or four objects. Or, if you'd like to work with something a little different, find an interior view in your house that would pose an interesting but not too difficult drawing problem.

Because you will be working with thin paint, the surface you choose will be a significant factor in the final outcome. A stretched canvas will absorb more of the color as stain, and the tooth of the weave will provide a textural dimension. If you choose to work on Masonite or a canvas board, the paint will tend to stay on the surface, exposing more exaggerated brushwork. You may have to work with your support flat on a table to keep the paint from running.

Make your initial drawing with a pencil, scribbling lightly on the surface with gesturing motions to locate your forms. It does not pay to be too deliberate with your pencil lines because you'll probably have to change them. Charcoal rubs off more easily as you edit out mistakes, but its black dust will be dissolved in your paint and muddy your color. Proceed to lay in your paint, diluting it first with turpentine and a small amount of one of the mediums suggested earlier under "Materials." Washes made with turpentine alone tend to dry a little too chalky; the medium will cast a little sheen to the color. Do not make your mixtures so liquid that they run to the bottom of the canvas, dissolving the forms. You'll have to experiment to find a consistency of paint that sticks where it's brushed. But don't worry about a few drips here and there: It is the twentieth century, and drips and splashes are well within the vernacular of modern painting.

As you paint, try modeling some light areas by rubbing back to the white of the canvas with a soft rag, rather than just adding white. However, do both, since the contrasting techniques will sit well together. Make strong darks where they're needed, working with thin washes is no reason to eliminate them. Obviously, it's okay for your color to be opaque, as long as you don't let it get too thick. Finish this one alla prima. Remember? Only one painting session!

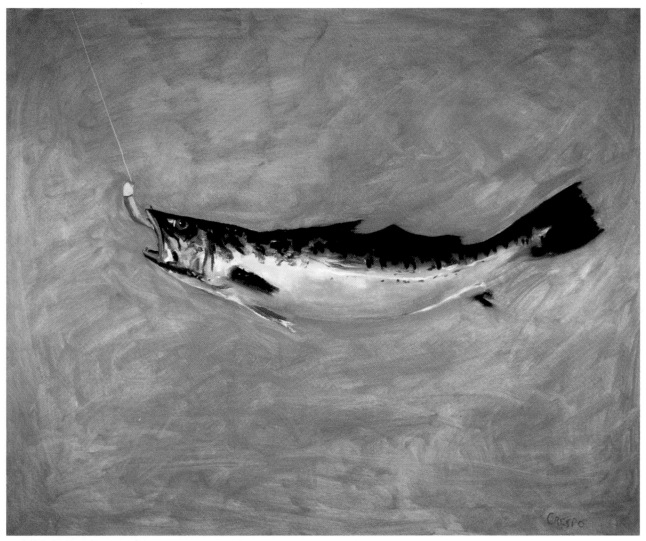

MICHAEL CRESPO, **HOOKED SPECKLED TROUT,** *1984. Oil on canvas, 24″ × 29″*
(61 cm × 74 cm).

*I originally intended to build up heavy layers of paint in this painting of "what I
would rather be doing," but as I swished on an initial underpainting of Gulf of
Mexico blue-green I became infatuated with the traces of my brush movements
and spent the better part of an hour pushing the wash around. I let it dry and
decided that the presence of the white of the canvas yielded an excellent version
of underwater illumination, and the bustling brushwork signaled agitated water.
I then painted the fish in thin yet opaque colors. On the belly and around the
gills I rubbed back through to the underpainting to establish a slight color
correlation from fish to field.*

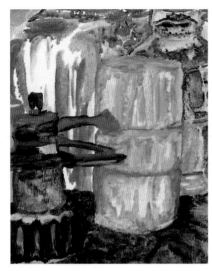

JANET JONES, *student work. Oil on canvas board, 10" × 8" (25 cm × 20 cm).*

JULIE CASEMORE, *student work. Oil on canvas, 12" × 9" (30 cm × 23 cm).*

Far left: Canvas board has a resistant surface, and when very thin paint is applied to it, the bubbly texture found in Janet Jones's painting can result. Janet capitalized on the outcome, allowing the shimmering texture to pervade her entire painting and unify the surface.

Left: Julie Casemore tied her objects tightly to one another, and to the surrounding space, with dark painterly brushwork around their perimeters. On stretched canvas such as this, the paint tends to saturate and stain more than on a canvas board, as in the blue drape at the right.

WENDY ROMERO, *student work. Oil on canvas, 12" × 9" (30 cm × 23 cm).*

Wendy Romero dabbed on paint with a soft brush to produce the vase in the extreme left. The ground plane is the result of a dense saturation of the blue pigment pushed around with a brush. She used a rag to blend the smears of color on the wall.

ANITA MITAL, *student work. Oil on canvas board, 9" × 12" (23 cm × 30 cm).*

Anita Mital wielded an energetic brush in this animated little piece. She left a lot of unpainted surface to represent the white wall behind the objects. (The odd splotches of color that feather whimsically down are paint splatters on the wall of our classroom studio.) Although Anita placed her objects somewhat eccentrically about the space, she has achieved an overall balance. The goblet's terse highlights beautifully elucidate its hard, glossy surface.

DENISE PLAUCHÉ, *student work. Oil on canvas, 11" × 14"* *(28 cm × 36 cm).*

Denise Plauché found thin paint quite suitable for fabricating her still life with a multitude of colored shapes. The black lines strengthen the contours of the various forms and accentuate the many colors.

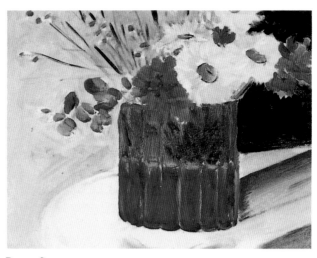

DIXON SMITH, *student work. Oil on canvas, 9" × 12"* *(23 cm × 30 cm).*

Dixon Smith began this painting with jabbing strokes that account for some of the texture, especially in the red and black. Ellipses, triangles, and parallelograms all form a logical contrast to the capricious flowers.

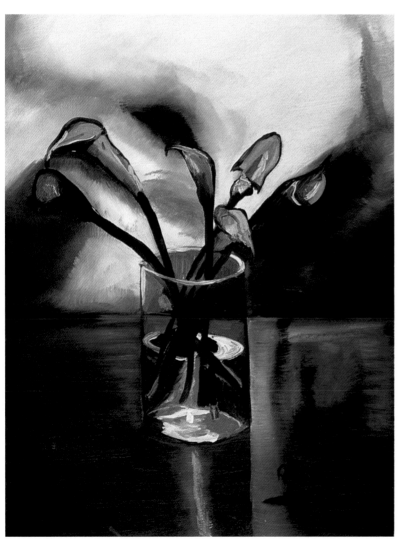

ARLENE EARHART, *student work. Oil on canvas, 18" × 14" (46 cm × 36 cm).*

Arlene Earhart casts an almost mystical spell in this painting of fresh-cut calla lilies. She used a blending brush to nudge the colors of the background into fantastic billowing forms, and to lighten the ominous surface of the table with glimmering reflections.

Impasto

Impasto, the Italian word literally defined as bread dough or paste, came to describe a style of painting in which brushstrokes are deliberately rendered in thick, luscious slabs of paint—a startling contrast to the ephemeral washes of your last painting. I suggest that you peruse a few art books, or if you are fortunate, visit a local museum, and look for those works in which the paint surface no longer simply amplifies the tooth of the canvas, but buries it beneath layers of sculptural relief. To cite but a few: Vincent van Gogh's short, caked strokes are plastered across his canvases in tight-knit patterns, marching in multitudinous directions. Rembrandt's self-portraits map the fleshy planes of his face in dense, spackled colors. It would seem that to run your fingers across one of these paintings would surely reveal the actual contour of the master's countenance. Modern genius Hans Hofmann trowels great silent slabs on top of juicy, swirling fields in his powerful abstractions.

Impasto can imply weight. Not only is there the reality of the physically heavier surface immediately recognized, but even the most sprightly colors and values appear more grave and leaden. Light striking an impasto surface reveals a more exaggerated terrain, with actual cast shadows becoming part of the visual dialogue—painting nudging the boundaries of sculpture.

Exercise: Exploring Thick Paint

Set up a still life as simple or complex as you wish. Work in any size format you like, but I caution that you will be using a great deal of paint and may wish to conserve by choosing a smaller canvas. Lay out your full palette of color and begin to lay in washes as you did with thin paint on page 28. However, do not use any medium other than turpentine to observe the "fat over lean" dictum mentioned earlier in the discussion on mediums. Try to approximate local colors as you develop your painting. (A local color is one that is derived from the nature of the object portrayed, such as a red apple, green leaf, or blue sky.) Find nuances in color, but stick to what you're seeing. Use slightly thicker paint as you move along, but do not utilize any impasto today. You should stop when your painting is close to finished and dispense with any detailed work. Let it dry for a day.

When you return to work, consider the local colors you have used and set forth a task of intensifying those colors as you work back into your painting. Proceed to paint using thick globs applied with brushes and palette knives. You will immediately note varying effects. The consistency of the colors as they come from the tube is often ideal for impasto painting. If needed, you may introduce a little medium into your mixtures, but be careful not to make the paint too runny. Should you need to lay another color on top of a wet stroke, do it with a delicate touch, just depositing it onto the surface of the color beneath without disturbing it. It may take a little practice, but you'll master it in time. It's a necessary technique for laying highlights onto a contour. Either a brush or a knife can be used, but a brush with long, soft bristles (such as a synthetic sable) is the ideal instrument.

Explore different thicknesses and consistencies of the paint, and by all means indulge yourself in the sheer jubilance of play that is inherent in manipulating the succulent oil colors.

Thick, oily impasto is illustrated here. The blue shape was textured with bits of dried paint scraped from the palette and mixed with the wet color. The yellow and white marks at center were deposited on the thick paint with a soft sable brush.

In this example, thick paint was scraped with a knife across a contrasting surface of already dry washes. The contrast of impasto to wash can create a strong spatial illusion.

Diatomaceous earth was added to this drier-looking impasto applied with a stiff brush. The values and colors are close, placing more emphasis on the texture.

DONNA MARTIN, *student work. Oil on canvas, 9″ × 12″ (23 cm × 30 cm).*

Donna Martin built her impasto surface methodically, allowing various stages of paint thickness to remain visible. The lower left corner indicates an initial wash wiped on with a rag. The paint at the top center is certainly thicker, but by no means as thick as the curdled pigment that forms the two shells on either side of the composition.

GRANT SCHEXNIDER, *student work. Oil on canvas board, 9″ × 12″ (23 cm × 30 cm).*

As Grant Schexnider brushed on thick, oily paint, he simplified the surfaces of the seashells into abstract shapes, at the same time keeping intact the evidence of a strong overhead light source. The downy texture of the forms in the foreground was made by stippling a brush with stiff bristles into the wet colors. This airy illusion plays well against the flat zones of color to the right and the long, juicy vertical strokes of the background.

LAURA GERNON, *student work. Oil on canvas board, 9″ × 12″ (23 cm × 30 cm).*

Laura Gernon systematically changed the directions of her strokes as she moved across the planes of her painting. The thick, sliding paint appears transparent in places because of an excess of medium added to it. This is usually referred to as "long" paint because it can be easily dragged a distance across the canvas. Laura used seductive cool tones and values in the shaded area of the foreground. This quiet, contemplative passage is set off by the blatant high contrasts of its environment.

DENISE PLAUCHÉ, *student work. Oil on canvas, 18" × 14" (46 cm × 36 cm).*

JULIE CASEMORE, *student work. Oil on canvas, 12" × 9" (30 cm × 23 cm).*

Above: Julie Casemore worked with "short" paint—that is dry, gummy paint that does not travel very far on the brush. With it she conveyed a profusion of nuances of color and value that she detected on the surface of the shell. Julie continued the black of the background down into the ground plane, dense against the contour of the shell, but fanning out to blend with the white of the foreground.

Left: Denise Plauché applied slabs of stimulating colors with her brush, and then began disturbing the planes with the sharp end of her brush handle. The result is the network of engraving that serves to blend the sometimes very disparate color combinations. Using a soft-bristle brush, she finished with white highlights and flecks of colors on the wet surface.

Denise clashed together opposing temperatures to produce an unearthly light. These shells could easily be resting on the surface of the moon.

MICHAEL CRESPO, **MOURNING DOVE,**
*1983. Oil on canvas, 20″ × 24″
(51 cm × 61 cm).*

*For this painting of one of the doves
that rest on my studio window ledge, I
built up the surface by using a large
brush to plaster on globs of paint that
had been mixed with marble dust to a
paste consistency. The dove itself
began as a very thick shape of white
paint, which I then modeled by rolling
a loaded brush into the wet white. I
was attempting to make the painting
appear as if it had not been painted
with a brush, when in fact it was
entirely brushed.*

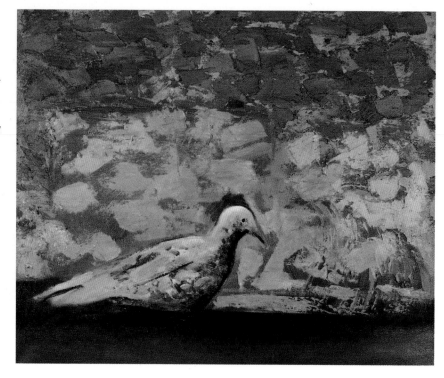

JOSEPH HOLMES, *student work. Oil on canvas, 16″ × 20″ (41 cm × 51 cm).*

*Left: Joseph Holmes built the impasto
surface of this impressive landscape
by continually reworking and revising
it over a period of time. This much
layering usually produces a crusty
texture, and the edges of forms
eventually become very irregular
because of the pits and scars of the
surface. Joseph compensated for the
rough edges by pushing his ranges of
both value and color intensity to
extremes.*

*Right: This is one of a series of
abstractions I was making in the late
1970s that involved the Gulf Coast as
subject matter. I built up heavy layers
of paint using a medium that con-
tained beeswax. The wax gave the
paint a stiff but creamy character with
a very matte finish. Tiny coquina
shells can be seen as lumps on the
surface of the pale yellow vertical
band on the left, and sand is evident
in the brown and tan area above the
central black band.*

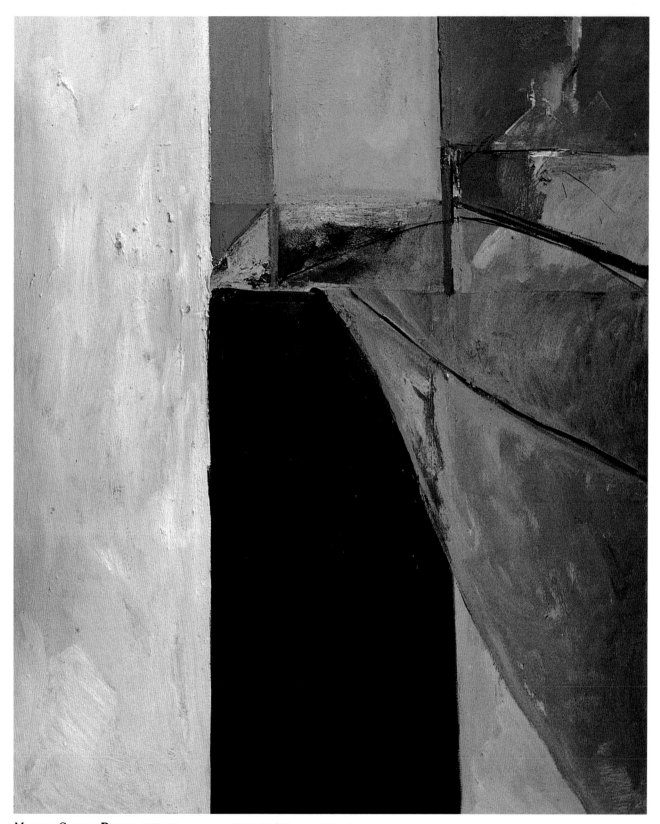

Michael Crespo, **Dunes,** *1977. Oil on canvas, 60″ × 51″ (152 cm × 130 cm).*

Modeling Form

Paint plays two essential roles in the hands of the artist. It can be a substance of description, with which we illustrate the people, places and things of our physical and cerebral environments. Or it can be the subject of itself, a purely visual twinkle of energy, suspended on a surface, existing solely as a gesture of the painter who deposited it there. Surely at some time in the hours spent painting thus far, you've found yourself meditating, in the warmth of well-being, on some small juncture of paint that merely "seemed right" and was simply wonderful to look at.

In the process of painting we cannot escape constantly juggling the two, seeking some balance between the portrayal of subject, whether that portrayal is figurative or abstract, and the actual physical presence of the paint. This balance need not necessarily be equal. Our quest for personal expression demands great leniency in how and where we direct the paint.

You are about to begin two paintings in which you will use the paint more as an illustrator of form than as a form in itself. To do this you'll practice some subtle modeling techniques, virtually eliminating brushstrokes.

Exercise: The Blending Brush

Before beginning your painting, practice with your blending brush. Using a basic drapery fold as a study will also provide an approach to that sometimes difficult, ever-present subject. Study the illustrations on fold structure and attempt some similar studies on paper using black, white, one additional color, and of course your blending brush.

One basic technique for blending is to begin by laying down your dark, medium, and light values in simple planar shapes. Then, using the blender brush, lightly stroke back and forth across the boundaries of the values until a smooth transition is achieved. It

may be necessary to add more black and white from time to time to recapture lights and darks.

Another method is to lay down only the dark color and add white with a brush, mixing the middle values on the surface as you move across the form. In the course of your experimentations, you may discover other variations in technique that work best for you. As always, do what you must do and let your eyes guide you.

Exercise: Still Life with Modeled Forms

Select two white, smooth-surfaced objects and a piece of dark drapery for your still life. Attach the drapery to a wall and arrange some deliberately simple folds. Arrange the objects on the drape and illuminate from above with your floodlight. Choose a support, any size you wish, and make a drawing from your setup. Draw the objects at least life-size or larger to make room for modeling with your blending brush. Lay in your painting, and as you develop it use only your blending brush and the softer synthetic sables which will keep the paint surface smooth. Bristle brushes tend to leave traces and make irregular transitions. Remember, this painting should be free of brushmarks.

As you work, keep the edges of your forms crisp and your value and color transitions as gradual as possible within them. Do not starve your painting of color just because the setup is relatively simplistic. Try to subtly introduce as many colors as possible. Minor temperature changes can be whisked in with your blending. These nuances of color will be especially important in modeling your white object, because white forms are very seldom simply black and white, but reflect and assume colors from their surroundings and from the light. Take your time. It's not necessary that you finish this particular painting in a single session.

Both sides of the protrusion are visible in a basic fold. The top is the lightest value, the sides middle gray, and the base dark. In the study at left I used my blending brush to mix alizarin crimson, black, and white.

An undercut fold flops over, obscuring one side. The dark base appears right next to the light top of the fold. On the other side, the value darkens gradually. Stroke your blending brush in the direction of the fold.

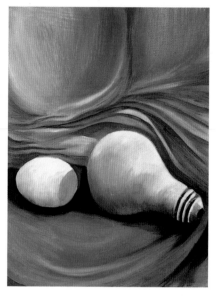

GRANT SCHEXNIDER, *student work. Oil on canvas board, 16″ × 12″ (41 cm × 30 cm).*

In this carefully modeled painting, Grant Schexnider discovered a forceful winglike shape in the background drapery, and coaxed it out of the dark shadows, making it a major component of his painting. His value system of extreme lights painted on, or emerging from, a dark void is known as chiaroscuro.

DONNA MARTIN, *student work. Oil on canvas board, 16″ × 8″ (41 cm × 20 cm).*

Donna Martin developed her painting with flicking strokes of her brush, subtly fusing the diverse values in a grainy atmosphere. The paint-stained piece of paper and table in the foreground are a startling contrast to the contemplative light that descends from the top.

TODD PALISI, *student work. Oil on canvas board, 12″ × 9″ (30 cm × 23 cm).*

Todd Palisi directed the thin folds of his drapery into a vortex that engulfs the two objects and their dark shadows in streaming currents of movement. The tiny brush lines in the thin paint move with the contours of the folds and forms, changing direction in every shape. Todd added a little color jolt with the acrid yellow egg.

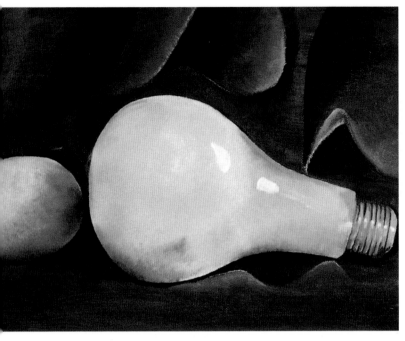

GLENDA SPIKES, *student work. Oil on canvas board, 9″ × 12″ (23 cm × 30 cm).*

With her blending brush, Glenda Spikes arrived at a very smooth texture. Her drawing is precise, and the highlights that shine on the glass and metal of the bulb not only hint at reflected light, but help establish volume by pulling the surface toward the viewer. The blue with which she modeled the darks on the white objects becomes a relatively intense color focus.

MICHAEL GUIDRY, *student work. Oil on canvas, 11″ × 14″ (28 cm × 36 cm).*

Michael Guidry feathered his paint in vertical movements as he portrayed strong overhead light. Intent on not being dull, he masked the white objects in tangy complementary tints of yellow and violet, and exploited shape in the background by folding the drapery in hard-edged stripes of light. He took a similar stance in painting the objects, yielding a stylized version of their geometry.

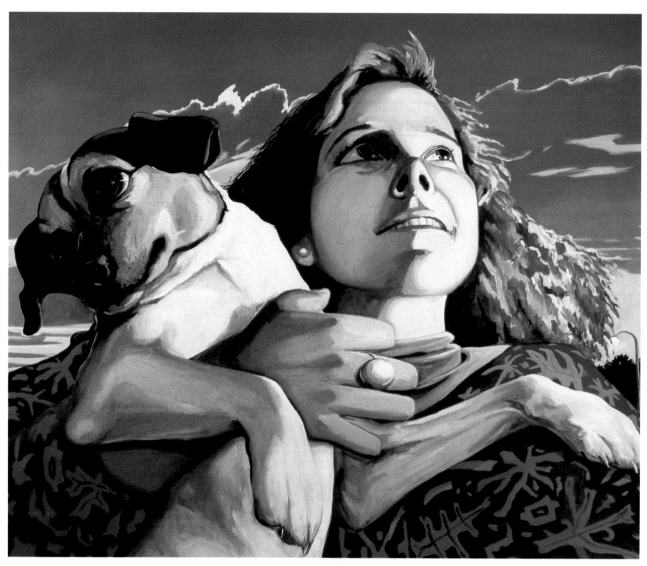

LIBBY JOHNSON, **HOLDING A DOG UP IN THE SKY,** *1988. Oil on canvas, 60″ × 70″*
(152 cm × 178 cm).

Libby Johnson painted these two large-scale figures from a point below them. A heroic light, born of intense artificial studio light and dramatic natural light in the landscape, reveals hordes of colors that are gathered into vibrant unified surfaces. In the girl's face alone there are variations of orange, pink, red, blue, violet, and gray. Note the passages of warm and cool that form the dog's white fur, and the many colors in his face.

ROBERT HAUSEY, **DEPOSITION OF THE MUSE,** *1987. Oil on canvas, 78½" × 117½"*
(199 cm × 298 cm).

*I safely speculate that Bob Hausey has painted every conceivable fold known to
drapery in this imposing version of one of his recurrent themes. Impeccably
smooth value modulations enhance a profusion of shapes of light as they play
across figure and cloth. In the small red drape at center, Bob has provided a
very powerful focal point, to which our eyes constantly return as they are
channeled about through this maze of overwhelming dramatic staging and
virtuoso technique.*

Defining Planes

When flat shapes relate to one another in such a way as to give the illusion of a third dimension, they become planes. Planes direct the eye through space and give volume to forms. We copy them directly from nature, or we invent them to help clarify the space in our paintings. There are planes in any landscape, on your face, and on an apple. The planes of a craggy mountainside are easily discernible; the planes of an egg are not. However, they can be interpreted by noting the changes in direction of the surface; rather like constructing a three-dimensional model of an egg by folding a piece of paper.

I remember my first major revelation as a young painting student occurred when my friend dragged me to the Barnes Collection in Merion Station, Pennsylvania, to feast on the many exquisite works there by the French painter Paul Cézanne. His still lifes, landscapes, and figures all reveal a powerful continuum of geometry that erupts from within a form, punching out the surface and leaving it mottled with planes of color. Peaches, mountains, bodies, sky, and water all had the same planar structure. I was struggling with drawing at the time and his paintings gave me new insight. I began to see in planes of color. Even when I drew in pencil, I imagined a color for every plane I recorded as my eye moved across the surface of all that I saw. No longer was painting a hand difficult, it was the same as painting a pear— just planes in a different order. Cézanne's influence has been powerful in modern art, but I received an intimate private lesson that afternoon at the Barnes, a lesson that still resonates through my work and through my teaching.

Before you commence this painting session, spend a little time with Cézanne, via either a book or a museum. What you see will help guide you through this painting. I asked on page 22 that your mind's eye view the world as flat shapes. I ask you now to see a topography of planes of color and value.

Exercise: Interpreting Planes

Make a still life with multiples of an object whose surface at least suggests planes, such as a pile of potatoes, apples, seashells, or rocks. Light your subjects well to aid in exposing potential planes. Don't skimp on the size of this painting; again, it will help if you paint your objects larger than life. Why not work on a surface a little larger than the largest you have used thus far?

Let's utilize another technique of drawing on canvas. Mix a fairly diluted solution of ultramarine blue and turpentine. Load a small round brush with this wash and begin drawing directly on the canvas with lines of blue paint. If you err, simply wipe out with a rag dipped in turpentine, or just correct the line with a stronger blue line. An advantage of this process is that you can leave some, or all, of these colored lines in your finished painting.

Scrutinize the surfaces of your subject and draw the planes that are implied. Invent if you need more. Exaggerate what you see! Break up the surface of each object as much as possible. You may refine more when you paint. As you begin to paint, pay close attention to the light as it illuminates the surfaces. These lights and darks must be translated into the planes you've drawn. Well-placed values will greatly aid the three-dimensional illusion. Make color changes, either drastic or inconspicuous, as you move from plane to plane, remembering the theory that warmer, lighter, or more intense colors tend to come forward, while cooler, darker, or grayer colors seem to recede. This can be very helpful in trying to locate planes in space relative to one another.

Remember also that brushstrokes are planes and can be applied with great spontaneity and flourish at any point in the process. Paint on until volumes emerge and space is delineated. I recommend more than one session on this one. Layering the paint will help build the illusion of depth.

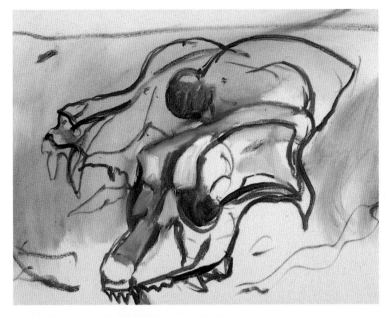

I began my painting of two animal skulls by drawing with a brush loaded with ultramarine blue thinned in turpentine. Corrections in the drawing can be made by wiping out with a rag, using heavier, darker value lines, or—as in the case of the front skull—covering with a little white paint. The thin wash will dry quickly, so you need not wait to begin painting.

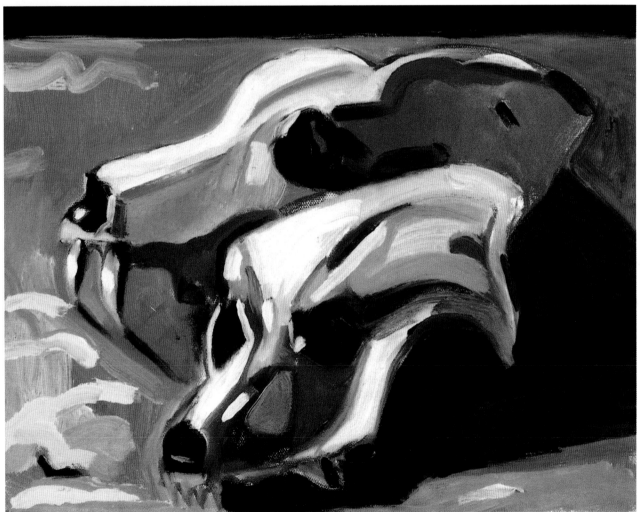

The harsh light I cast on the two forms helped greatly in simplifying the complicated contour of the skulls. I painted clearly defined planes of light, middle, and dark values of colors significantly grayed. One should be able to visualize climbing through this painting like walking up stairs.

ANITA MITAL, *student work. Oil on canvas board, 12" × 16" (30 cm × 41 cm).*

This lively study by Anita Mital conjures up the paintings of the cubist movement. While extracting planes from her subject, she simplified them into crude, straight-edged geometry, not unlike the method of Pablo Picasso. And although Anita further exaggerated her idiosyncratic structure with boisterous color, the underlying organization of planes is still one of careful observation.

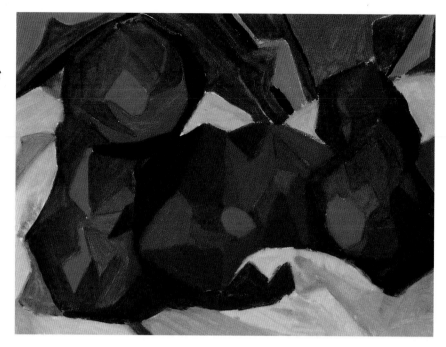

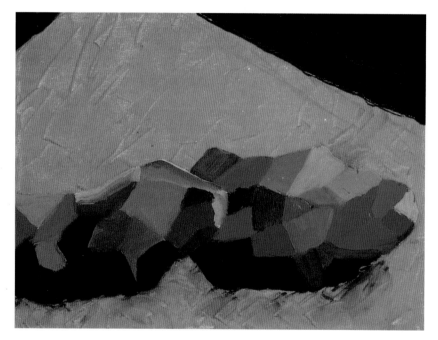

LAURA GERNON, *student work. Oil on canvas, 9" × 12" (23 cm × 30 cm).*

Laura Gernon makes no bones about a planar statement. Her potatoes appear to have been carved out of granite, their facets clearly marked in values that chart the light entering from the top right. These leaden vegetables rest on a plane of electric cadmium orange, energized even more by the flat black of the background.

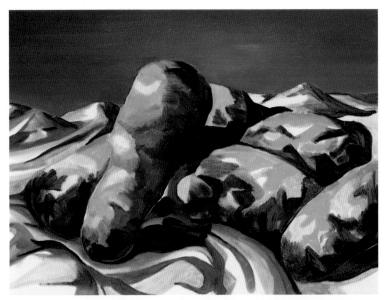

TODD PALISI, *student work. Oil on canvas board, 12" × 16" (30 cm × 41 cm).*

Todd Palisi's frugal application of yellow and green not only centralizes the focus of his composition, but greatly emphasizes the volume of the potatoes as methodically disclosed by planes. The flat band of "sky" across the top and the "mountains" of drapery on the horizon give the painting a decidedly landscape feel. And with its sparse color, the class appropriately titled Todd's work "Potatoes on the Moon."

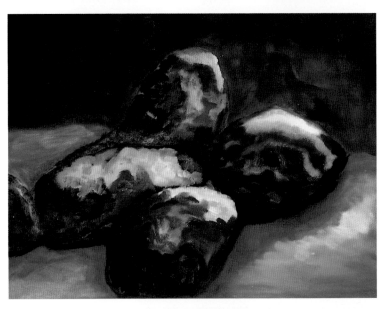

SHARON SYLVESTER, *student work. Oil on canvas board, 12" × 16" (30 cm × 41 cm).*

Sharon Sylvester's painting evokes a more mysterious space, rich in color and contrasting light. Her planar framework is based on the mark of one brush, which she applied across the space in an agitated manner. Although each brushmark does identify a plane, it's the clustering of marks into larger planes of value and color that takes precedence. Sharon worked through a commendable array of transitional colors as she moved from the dominant cool tones to the glowing highlights.

DONNA MARTIN, *student work. Oil on canvas board, 12" × 16" (30 cm × 41 cm).*

Donna Martin set up a miasma of black and white, into which she rendered the potatoes in tiny multicolored planes. The planes do their job well, explaining volume as they are dispatched across the surfaces logically—cool in the shadows, warm in the highlights. It's important to note that when planes are small and in great numbers, the effect is that of a more gradual surface. Despite the complex planar facade of these potatoes, they seem a little more akin to eggs.

STEPHANIE DeMANUELLE, **UNTITLED,** *1987. Oil on canvas, 18" × 24" (46 cm × 61 cm).*

Stephanie DeManuelle often paints from still lifes consisting of fragments of pottery and natural objects strewn about folds of drapery. Here dry, scumbled paint vigorously anoints the surfaces of diverse rhythmic planes that writhe together like snakes. The smaller triangular plane in the central foreground echoes the solidity of the dominant pyramid and sets off the well-balanced halves of the canvas.

LIBBY JOHNSON, **EGGPLANTS,** *1985. Oil on unstretched canvas, 9" × 12½" (23 cm × 32 cm).*

Libby Johnson laid juicy brushstrokes of various shades of purple over a red underpainting in bandlike planes to simulate that strange inner glow that sometimes appears in the skin of eggplants. Libby altered the direction of her very active brush from plane to plane, further emphasizing the illusion of shifts in the surface.

Lynette Knight, **George on Couch,**
1987. Oil on canvas, 63" × 46"
(160 cm × 117 cm).

*Lynette Knight used planes of primary
colors to paint this view of her friend
George asleep on a sofa. She's
restricted all her planes to straight
edges, with the exception of a few that
arc slightly. This results in a very lucid
yet mechanical interpretation of the
form, which strengthens the pervading
diagonal thrust of the composition
from lower left to top right.*

Primary Value Systems

In paint, the manifestations of light are interpreted by merging value and color. Of course, mere black and white can produce an impression of light. And color has its own inherent light—its chroma, or intensity, which can illuminate without changes in value. However, only when the two are fused can their separate potentials to exude luminosity be fully exploited. Always keep color and value tightly attached in your thinking and mixing, especially in the two paintings you are about to do as you investigate some basic schemes for painting light.

There are three primary systems of value/color: normal, high-key, and low-key. By your own instincts, and goading from me, you've been painting thus far in perhaps the most flexible of these systems, the normal value range. In this system the values range from white, through the middle values, to the darkest color you can make. Most of the colors used are clustered around the middle, with extreme lights and darks used primarily as accents.

In the high-key value system the range is restricted. White is still the lightest light, but the darkest dark is now the middle value of a normal range.

In the low-key value range the middle value of the normal range is the lightest light. All the other colors are darker, moving toward the darkest black.

Exercise: High-Key Painting

Select a single object as your subject, and choose a canvas that will allow you to paint your object approximately five times larger than it is. It's an exercise in monumentality; a 6-inch pear would become a 30-inch image. This drastic scale change should alter your approach, placing slightly different demands on your technique. You may have to make larger brushstrokes, and your object will have a larger area of contour for you to contend with. Your experience with seeking planes in the last painting may prove useful here.

Position the object in a simple environment, and light it so that a normal value range is clearly evident. Sketch it on your canvas using any one of the methods we've covered, and begin to lay in colors that fit into the high-key value range. First, sight the darkest spot in the setup. This will be assigned a middle value, which can be determined by matching a color to the central value in the scale that you painted earlier (see page 11). All the other colors will be lighter in value. You should use a lot of white in your color mixtures, and resist any temptation to punch in a few darks. This painting should have the light of a bleached day on the beach.

To compensate for the limited value range, try to make as many color changes as you can to enliven your painting. Paint until you're at least reasonably satisfied with your image, whether it takes two hours or two days.

Exercise: Low-Key Painting

Choose another object and place it in a similarly lit setting. If you enjoyed blowing up the form in the last painting, do it again. Or paint it actual size if that would make you feel more comfortable. Make your initial drawing and begin to lay in your composition, this time sighting the lightest light of your still life, usually a small highlight, and paint it a middle-value color, rather than the very light color you're seeing. Your value range of colors will now extend from it to the darkest dark you can mix. Try not to jump above this middle value, and again, make as many color changes as possible to move the eye around this dark, brooding scheme.

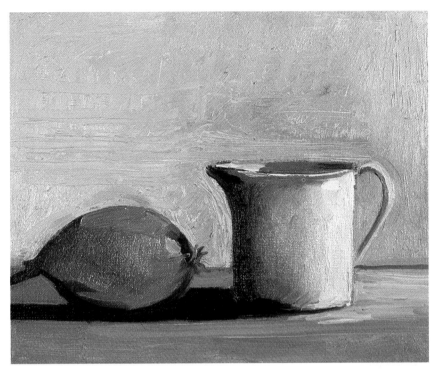

In this example of a normal value system, a range of middle grays is punctuated with smaller areas of extreme dark and light.

A low-key value system establishes a somber, almost brooding atmosphere with deep darks highlighted by middle gray values.

In a high-key value system, a middle value becomes the darkest dark, and the painting is flooded with bleached, light color.

LEA ALFORD, *student work. Oil on canvas, 24″ × 20″ (61 cm × 51 cm).*

DENISE PLAUCHÉ, *student work. Oil on canvas board, 16″ × 12″ (41 cm × 30 cm).*

Denise Plauché applied lush impasto paint to form this image of an ornamental gourd in high-key colors. She ran an extensive range of colors through the painting, which makes it almost seem to dance. Her darkest value does not drop below the middle range, and she covered large areas with slightly tinted whites.

Lea Alford conceptualized a parched, planar landscape in faint tints of blue, orange, and green. Although perspective gives us clues to depth, the abstract break-up of value and color (instead of local value and color) gives the painting its push/pull sense of space. Many little background areas press forward, and many foreground shapes recede.

ALAN FONG, *student work. Oil on canvas, 16″ × 20″ (41 cm × 51 cm).*

Alan Fong launched this enlargement of an ornate teacup with the middle gray shadow as his darkest dark. However, in the end he accented the cup's handle with a definite dark that causes it to float out from the decidedly high-key space. The yellow hue advances away from the gray of the back inner lip, pulling the front of the cup out a bit and giving it a sense of volume.

CHRISTOPHER JOHNS, **BODY AND SOUL #2,** *1982. Oil on canvas, 84" × 72"*
(213 cm × 183 cm).

*In this generous abstraction, Christopher Johns kept the value of his color high-
key in order to let its chroma stake out the space. Different-size shapes of
orange, red, and blue are suspended in a vast field of neutral gray, where,
entwined in wiry fragments of line, they are free to jockey for position. Is the
large orange shape closer to you than the large blue shape at the bottom left? Is
the small orange shape closer than the large central blue-green shape? And
where do the red stripes fit in? These questions are difficult to answer, for Chris
has cleverly set all his compositional elements in motion. The space changes as
we consider different relationships.*

LIBBY JOHNSON, **ORIENTAL VESSELS,** *1988. Oil on canvas, 36″ × 24″ (91 cm × 61 cm).*

The foreground and background of this painting are one continuous shape that does not vary an iota in value or color. Normally this would provoke a very flat space. But Libby Johnson relies on a severe black shadow to imply a ground plane, and skillfully renders illusions of volume to carve out the round vessels. The dark tonality suggests great depth, like the endless dark sky or dark water. Thus, by employing a ghostly, nocturnal light and some clever cues, Libby coaxes us to experience substantial space in a great flat field.

GLENDA SPIKES, *student work. Oil on canvas, 16" × 20" (41 cm × 51 cm).*

In this well-crafted low-key painting, Glenda Spikes surrounded the gourd with a dense layer of smoke that rises to permeate the red-orange background. She kept her value range below middle, but successfully utilized color intensity to simulate bright light.

MICHAEL GUIDRY, *student work. Oil on canvas, 16" × 20" (41 cm × 51 cm).*

Michael Guidry playfully rendered a string of bell peppers in his low-value effort. He employed blatant perspective with huge peppers jamming the foreground, decreasing in size as they move toward the far edge of the table. His animated shaping and strong use of rhythmic line keeps them moving.

Without Brushes

I would never try to convince you that brushes are not the most perfect instruments for creating an image in paint. By now yours are probably feeling like natural extensions of your hand, and no doubt, one or two have become old friends and perform regularly during your painting sessions. But for the moment I'm requesting that you abandon them and consider some alternative painting implements that will expand your tactics, and provide the diversion sometimes needed to spark creativity.

Fingers. Who cannot revel in remembering the wondrous satisfaction of making finger paintings as a child? Your tiny hands, dripping with colored paste, mashed and traced delightful, unbridled images into the surface of wrinkled paper. Now consider using your fingers to do subtle blending and modeling, as well as applying the expressionist marks and squiggles of your adolescent works. I strongly recommend that you wear examination gloves for any prolonged painting with your fingers.

Palette Knives. Palette knives have long rivaled brushes as popular painting instruments. Not only ideal for mixing pigments, they are superb tools for applying impasto slabs of paint, as well as scraping paint from the surface. The latter technique is useful for correcting mistakes, or as a constructive painting technique. Dragging the tip of a knife through wet paint can produce some fine linear effects, especially when there is a contrasting color to expose under the wet paint.

Rags. Needless to say, rags are essential for clean-up and corrections. As mentioned earlier, they can also be used to model a highlight by rubbing back through paint to the surface of the canvas. In addition, they are well-suited applicators for rubbing color into the bare white of the canvas, scumbling paint over another color, or sponging on and mingling wet, luxurious washes. The contemporary American painter Mark Rothko was known to use brooms wrapped in color-soaked rags to paint his giant atmospheric abstractions.

Dripping and Pouring. The American abstract expressionists did a great deal to redefine paint application. Dripping, pouring, and splattering paint were emblems of their liberation. Who can forget the photographs of Jackson Pollock dripping and pouring vast expanses of canvas on his studio floor? You can do likewise with colors mixed and poured from some container. Many times I first arbitrarily drip and splatter my canvases with many colors as underpainting—a prelude to developing form.

Anything Goes. There is an immeasurable supply of painting implements in your home, garden, and garbage. You've only to seek and experiment. Old credit cards and scraps of cardboard make excellent squeegees for dragging paint across the surface of the canvas. Sponges, cotton balls, and plastic wrap are excellent for stippling paint. Hair combs produce wonderful textures in wet paint. Dish mops, whisk brooms, and feathers are no strangers to the painter's studio either.

Exercise: Painting with No Brushes

Set up a still life of your choice. For this problem, I always favor a pineapple as subject for my students. The fruit has such an array of textures, not to mention its expressive stature. If you wish, begin with a sketch on your canvas, or plunge right in, mapping out your composition as you paint. I'm issuing only one order: No brushes!

Consider some of the alternatives I've discussed, or establish a few of your own. Use one tool or ten, just no brushes. You'll be surprised by the many fresh, new techniques you'll discover, while still deftly controlling the paint when needed.

*From left to right, paint manipulated with fingers,
palette knife, a rag, dripped from a cup, and scraped on
with credit cards and sponges.*

JOHN STRAUSS, *student work. Oil on canvas, 20" × 16" (51 cm × 41 cm).*

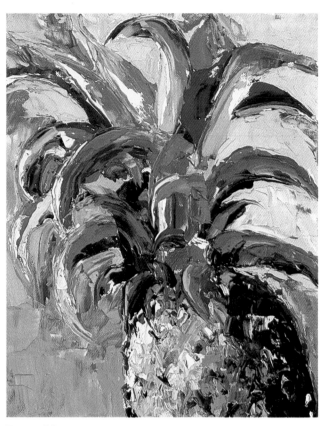

DONNA MARTIN, *student work. Oil on canvas board, 14" × 11" (36 cm × 28 cm).*

John Strauss relied heavily on his palette knives in this painting, but he also applied paint with rags to the softer folds of the blue background, and used his fingers to clean up edges and refine small details.

To render the surface of the pineapple, John deposited tones of yellow and red right on top of a thick wet underpainting. This wet-on-wet application requires a soft touch to prevent the mingling of the two layers of paint.

Donna Martin's cropped composition demonstrates two standard palette knife techniques. The pineapple's foliage, which fans out like a nest of cobras, was made by dragging the paint across the surface in slashing strokes, for well-defined shapes of color and value. The less distinct flesh of the fruit was formed by pressing the paint onto the canvas with short, jabbing strokes and very little movement across the surface. This stippling yields subtler transitions, giving the pineapple a more rounded appearance.

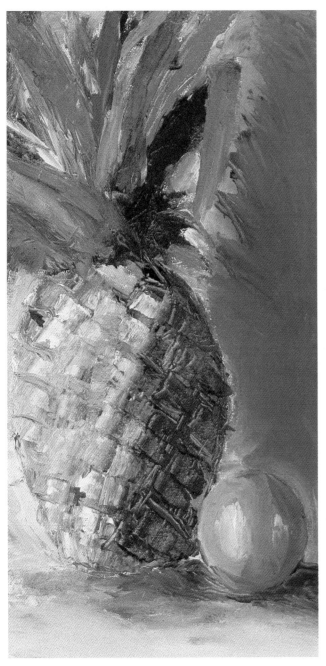

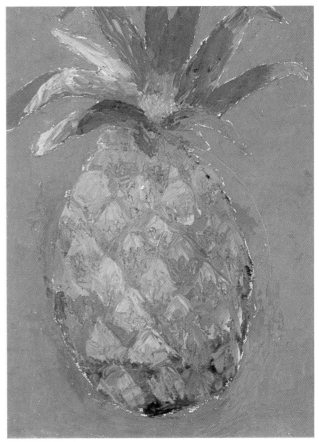

LAUREN CALLIHAN, *student work. Oil on canvas board, 16" × 12" (41 cm × 30 cm).*

Lauren Callihan explored a more decorative image that she suspended from the top of the canvas. She molded the pineapple with yellow-green diamonds on a gray-green base, and gouged out the spaces between them with a stick. Over them she's laid little three-pointed orange shapes that resemble the foliage and repeat the two values of the background. This echo of color successfully ties the figure to the field.

ALAN FONG, *student work. Oil on canvas, 16" × 8" (41 cm × 20 cm).*

Whether Alan Fong was using a rag, a knife, or his fingers, he kept the gestures dramatic and spontaneous, and the textures dense and intricate. The elongated format is very hospitable to the vertical value zones Alan has established. Note also the wonderful little bright yellow focal point placed on the pineapple at the juncture of flesh and foliage. It's engaged in an important visual conversation with its counterpart on the orange.

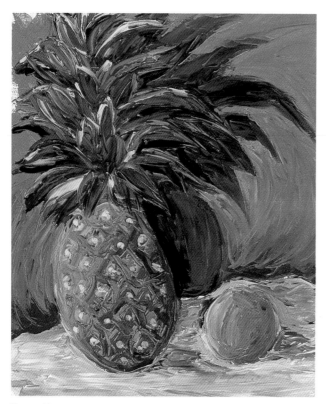

DOTTI BERRY, *student work. Oil on canvas, 20" × 16" (51 cm × 41 cm).*

Dotti Berry established an explosive contrast between the pungently colored pineapple, the blue background with its menacing shadow, and the broiling hues of the orange. The sober, neutral gray of the table further intensifies the color battle, as do the raking strokes of her palette knife. Dotti deliberately kept the top left corner of her canvas unpainted, which produces an interesting warp in the space as the white shape flies forward.

ANITA MITAL, *student work. Oil on canvas, 12" × 9" (30 cm × 23 cm).*

Anita Mital made her still life into a dynamic event. A stippled impasto surface forms the pineapple, frenzied finger painting mobilizes the animated blue shadow, and broad knife scrapes define the orange. Anita compressed the space into very tightly locked shapes by cropping the two dominant subjects at the edges. This brings the other shapes into greater prominence, which flattens the space somewhat. But depth is maintained by the placement of the orange in the lower right corner.

DENISE PLAUCHÉ, *student work. Oil on canvas, 18" × 14" (46 cm × 36 cm).*

Denise Plauché utilized a unique tool in painting this vibrant floral study: the common cotton swab. First she laid down the shapes in thick paint with a palette knife. She continued painting with the knife until her composition was almost completely resolved. Then, with cotton swabs, she worked over the entire surface of the canvas, inscribing the little furrows into the paint in varying directions, producing a highly decorative surface texture and spidery edges. Some of the linear darks on the blossoms were applied with the swabs.

MICHAEL CRESPO, **INFLAMED,** *1987. Oil on canvas, 62" × 72" (157 cm × 183 cm).*

I began this image of a malevolent spectre of a fish by mixing thin turp washes in a bucket and splashing them onto the canvas. After that I squeegeed paint irregularly across the surface with pieces of wood, and splashed on a thicker consistency of paint from my bucket. This is quite noticeable in the lower right quadrant.

Next I developed the fish by mixing a wax-based medium into the paint and worked different colors over the surface with my hands (which were protected with two layers of latex examination gloves). Finally I scraped back into the surface with knives and hair combs. I applied highlights and details with a knife and finished by slinging the bright oranges and yellows from my hands.

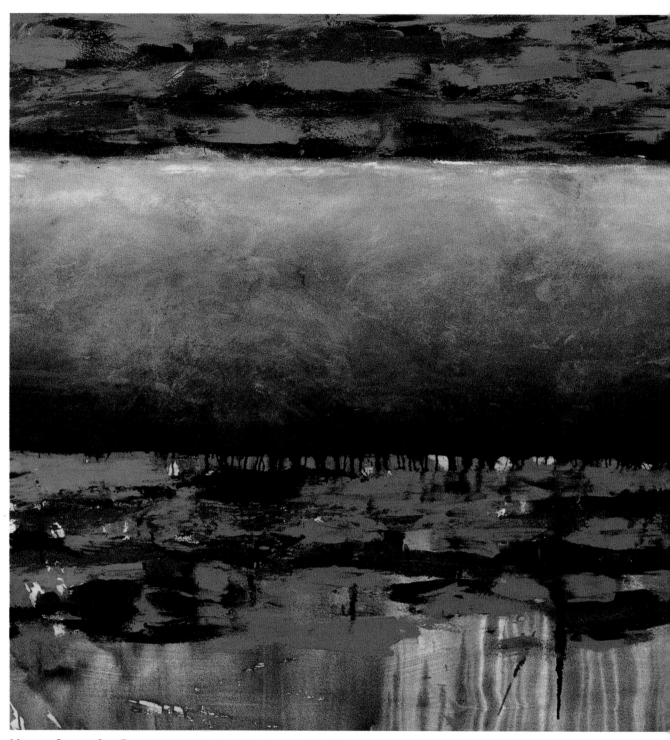

MICHAEL CRESPO, **SHE BATHES,** *1988. Oil and acrylic on canvas, 60″ × 120″*
(152 cm × 305 cm).

*This large abstraction, based on an underwater pipeline, was painted on two
5-foot squares of stretched primed canvas that were attached in the back. I
began by pouring on thin acrylic paint from a bucket, with the canvas tilted so
that the paint streamed off the bottom edge. The effect remains visible in the
finished painting.*

*With large masonry tools and oil paint I then built up the slashing blue
horizontal marks surrounding the tube. The tube itself was painted by sponging
on values of gray oil and then stippling the paint with a plastic garbage bag. I
did this by inserting my arms in the bag and rolling it in tractor fashion across
the wet gray paint. This imparted the soft, diffused, weblike texture.*

Color Harmony

I mentioned early on that in the course of this book I would expose you to some of the more general, encompassing color theories, because most painters tend to wander from tedious hypotheses, and prefer to construct their paintings in the trials and errors of their own instincts and perceptions. The most basic color theory does not dictate, but instead offers a sphere of possibilities in which the painter can move about, freely exploring and divulging personal expressions, attacking the more acute specifics of color theory if and when they arise. For the painting you are about to do, you will choose one of the four basic color harmony schemes to initiate your approach to color.

By definition, color harmony suggests a selection of colors that produces an aesthetically pleasing whole. The most elementary color harmony, monochromatic, is illustrated by moving one hue through a value range. Various tints (adding white) and shades (adding black) of the same color work together in perfect harmony, because no other color is present to suggest discord. When working in this system it is imperative that you articulate the solo color in a wide, sweeping value range. Drawing, light, and the intrinsic qualities of the hue itself are your only tools. In this starved system, changes in value tend to suggest changes in color. Likewise, variations in the texture of a color can trick the eye into sensing the presence of more than one hue.

Analogous harmony is achieved by using and blending three colors that are adjacent on the color wheel, such as yellow-orange, orange, and red-orange; or blue, blue-violet, and violet. The slow and methodical transitions between analogous colors, as well as their penchant for mixing together, yield a soothing, fused harmony.

Snappier, more ebullient moods are evoked by painting in the complementary and triadic harmony systems. Complementary colors such as blue and orange, red and green, or blue-violet and yellow-orange dazzle when juxtaposed in a composition. Triadic harmony involves amalgamations of colors that are evenly spaced on the color wheel, such as the primary red/yellow/blue triad and the secondary orange/violet/green triad. By using only three triadic colors, you can create striking color contrasts and a broad range of subtler mixtures in between.

Exercise: Creating a Harmonious Color Scheme

Although this is a color problem, form should be your primary motivation in selecting a subject. More than likely, you'll be inventing color. I chose some amaryllis blooms from my yard for my students to paint. Despite the dominant reds and greens establishing a strong complementary harmony, I discouraged my students from simply painting what they saw. I perched the vase on top of stacked tables, well above eye level, and aimed the spotlights from below, posing a more challenging alternate point of view for both perspective and light. I suggest that you do the same, or consider putting your subject on the floor for an equally stimulating diversion.

Choose one of the four color harmonies mentioned so far (monochromatic, analogous, complementary, or triadic) that you feel would best express your personality, current mood, or general outlook. Do not fear making a choice based on your emotions. Color is an excellent vehicle for channeling them.

Select the color or colors that fit your system, and paint away, wedding the concept of color to the light and form of your subject as you perceive it. Although I'm only assigning one harmony for you to explore, I strongly urge you to experience the other three in future paintings where color is not the major thrust of the assignment.

Monochromatic harmony. For this view of a balloon race, I used my favorite gray made by mixing ultramarine blue and burnt sienna. Black and white were the only other pigments used.

Analogous harmony. Blue, blue-green, and green were the adjacent colors on the color wheel that were used in this backlit vase of flowers.

Complementary harmony. One of my favorite objects, an old English biscuit jar, posed as model for this study in the complements yellow-orange and blue-violet.

Triadic Harmony. The secondary triad of orange, violet, and green dominate this study in triadic harmony, even though I made variations within the secondary colors.

JOHN STRAUSS, *student work. Oil on canvas board,*
18" × 14" (46 cm × 36 cm).

To bolster his monochromatic harmony of reds,
John Strauss activated the surface texture with
thick deposits of paint, bold shapes, and an
intriguing value concept. The blackish red of the
stems and leaves plays obvious foil to the white
and pink of the vase. Their blatantly contrasting
values are surrounded by an ocean of nuances.

EDWARD PRAMUK, **NOCTURNE,** *1989. Oil on canvas,*
72" × 74" (183 cm × 188 cm).

In this brooding, ethereal work, Edward Pramuk
exploited a snug analogous harmony so subtle
that at first it looks monochromatic. In the
brightest and largest blue rectangle a ghostly
standing figure shimmers in the light of a tiny
moon, encased by a leviathan linear profile. The
faint path of the moonbeam guides us up into
the horizontal rectangle of inky blue-violet that
accommodates the moon. Another subtle shift of
color and we're in the band of greenish-blue that
borders the entire painting.

GRANT SCHEXNIDER, *student work. Oil on canvas board, 18" × 14" (46 cm × 36 cm).*

Grant Schexnider combined two analogous harmonies of conflicting temperatures in this vividly staged painting. At direct center and top, he placed blossoms that display a range of colors from a deep, pure red through a series of red-oranges and yellow-oranges to the two intense yellow spots. The surroundings are stroked with shades of blue, blue-violet, and the blue-green of the leaves. We are distracted from all this color interplay by the curious addition of the pure white paint, which functions as two dazzling highlights on the pitcher at the bottom and curious tracks of decorative patterning on the blossoms at the top.

JULIE CASEMORE, *student work. Oil on canvas, 12" × 9" (30 cm × 23 cm).*

Julie Casemore established a blazing version of analogous harmony by placing red and yellow in a field of black and white. Her tangled drawing is well suited to the unearthly harmony of the two hot colors as they squirm across the composition, with no transitions, amplified by the stark black. Analogous colors usually produce a quieter effect when adjoined, but here the powerful temperaments of red and yellow practically jump off the canvas.

WENDY ROMERO, *student work. Oil on canvas board, 18" × 14" (46 cm × 36 cm).*

Wendy Romero departed from naturalism to produce this energetic study in the complementary harmony of orange and blue. She chose to assign the leaves the same blue as the background, but rather than exploit subtlety as John Strauss did, she not only differentiated them with a black linear outline, but scumbled a yellow-orange boldly around them and unexpectedly repeated it in the lower right and upper left corners. This curious tactic makes us work a bit to distinguish object from field. Wendy further dramatized her subject with an intense white that appears to lift the bouquet right out of the vase.

CAROL HACKLER, *student work. Oil on canvas, 9" × 12" (23 cm × 30 cm).*

Carol Hackler painted the complements of red and green on a dark field for dramatic contrast in her study of a sprouting red onion. Although the red hue is more aggressive than the green, the clawlike form of the green sprouts is more visually attracting than the elementary sphere of the red bulb. Therefore the two distinct segments of the subject are pleasingly balanced.

MICHAUX WHITE, *student work. Oil on canvas, 10" × 8"*
(25 cm × 20 cm).

MICHAEL GUIDRY, *student work. Oil on canvas, 12" × 9"*
(30 cm × 23 cm).

*The primary triad of red, blue, and yellow can
make a powerful color statement but is also
difficult to harness. Michael Guidry has
succeeded by merging color with perspective in
an explicitly drawn composition. We move back
in space from the yellow areas to the red to the
blue, which operate much like the sky in a
landscape.*

*Michaux White selected cadmium red deep,
cadmium yellow deep, and cerulean blue for her
primary triad, all heavily suffused with white. To
keep the vase's butterfly handles conspicuous in
the complex field of intensely colored shapes,
Michaux amassed the deep red around them,
forming an ideal focal point.*

ELIZABETH LEAKE, *student work. Oil on
canvas, 12" × 12" (30 cm × 30 cm).*

*There are very astute scale changes
in Elizabeth Leake's study in the
harmony of the primary triad.
Throughout the vase of flowers, she
dispersed a flurry of small shapes,
lines, and brushmarks, which she
situated among large patches of
simple, flat colors. The relatively small
area of yellow serves as a focal point,
and its solid vertical thrust steadies
the racing horizontal stripes of the
background.*

JIM WILSON, **BRIGHT MOMENT,** *1986. Oil on canvas, 68" × 78" (173 cm × 198 cm).*

Jim Wilson entwined the primary triad of red, yellow, and blue with the secondary triad of orange, green, and violet in this radiating portrait of a supermarket shopper. He toyed with the scale of his colors by graduating the doses—tiny squares of blue, larger yellow bag, even larger red shirt. And likewise, green lettuce leaves, larger orange clouds, and an imposing violet sky. No doubt Jim intended a theatrical sensation. With the dramatic color and curiously bright light, his lady could well be walking in front of a backdrop on the operatic stage.

JOHN OPIE, **BONNARD APPEARS . . .,** *1989. Oil on canvas, 42" × 69" (107 cm × 175 cm).*

John Opie told me that this moment of fantasy is based on a quotation he once read in which the French painter Pierre Bonnard mentioned appearing before the young painters of the twenty-first century on wings of butterflies. John depicted the painter appearing to art school students in a blaze of light with butterflies ascending from his palette. The vision is saturated with a comple-mentary harmony that is sparse but explicit. The studio glows with red-orange light from the painter's aura, and is populated with well-placed shapes of a subdued blue-green.

The Painted Line

Scratching a line in the dirt with a stick is not an art discipline, but an instinct. Man has always doodled in one form or another, from conjuring the spirits of the hunt with lines on a cave wall to building cities from a map of lines on a piece of paper. I cannot believe that there is anyone who has never communicated a fact or expressed a dream with the most rudimentary line. In our early training as artists we first learn to draw, refining our scribbles into eloquent visions. The line remains the product of a natural gesture, but as we unravel its mystery it becomes a powerful and essential tool of our livelihood, or avocation. Although we quite naturally think of line primarily as an element of drawing, it is essential that we investigate its potential in painting.

Brushes are the most versatile line makers because their different shapes, sizes, and bristle textures produce an assortment of lines. A soft synthetic sable round loaded with wet pigment can produce a fluid, well-defined line, while an old worn hog-bristle brush carrying dryer pigment straight from the tube will deposit an indistinct, irregular line. Just about any tool you've put to use so far can make some kind of line. A very rigid line can be applied with the long edge of a palette knife. Lines can also be scraped into wet paint with a palette knife or the end of a brush handle.

Lines can define the boundaries of shapes and the contours of volumes. They can be repeated or layered to form patterns. They can live on their own moving in any direction, in any formation. They are the stars of linear perspective, producing the illusion of distance, or three-dimensional space. They can also allude to space in other ways.

Width. Varying thicknesses of line can be produced by varying the pressure of your brush on canvas, or by using different-size brushes. Thick lines appear to stay on the surface, closer to the viewer, while thin lines tend to appear farther away. This initiates a spatial illusion.

Value. As we change the value of a line we also alter its position in the space. Darker lines seem closer; paler lines seem farther away.

Color. When lines are given hues all the endless antics of color are assumed. Hot yellow lines lash out at the viewer, while cool blue-violet lines tuck deep into the space. This is the obvious spatial effect. Any of the nuances of color theory that you've unearthed can be brought into play in linear form.

Emotion. And finally, we respond emotionally to different configurations of line: powerful jagged zigzags, elegant undulating arabesques, joyful trailing spirals. A very obvious mood, or timbre, can be established in a painting with a preponderance of a certain line type.

Exercise: A Painting Dominated by Line

Set up a still life with a number of objects of varying shapes and surfaces. The idea is to suggest as many kinds of line as possible. Begin your painting by letting your eyes wander around the forms, recording your findings with brushed lines of various colors. Continue until a composition begins to emerge. You may now wish to block in volumes or large areas of color. It is not necessary that line be the only element in this painting, just a very obvious one. A practical way of working would be to alternate back and forth from planes and washes to line. Of course, should you feel somewhat obsessive, go ahead and weave your entire painting in a web of lines. Paint on, exploring as many possibilities of line as you care to, varying the consistency of the paint as well as your tools. Follow where your painting leads; just make line predominant in the end.

KAREN PHARIS, *student work. Oil on canvas, 18" × 24" (46 cm × 61 cm).*

Karen Pharis drew linear inspiration from the profuse decorative surfaces of her objects. She managed to maintain a casual touch while faithfully recording the intricate patterns. Some subtle value modulations suggest volume in the white shapes, aided by the flow of lines that guide us across the contour. Karen breaks from her effective monochromatic color scheme to produce a surprising focal point of burnt umber in the bottom left.

BRYAN LUIKART, *student work. Oil on canvas, 18" × 24" (46 cm × 61 cm).*

Bryan Luikart wove both basket and shell with lines of subtly changing color and value in this distinctly lit painting. The countless lines, detailed with a small brush, produce articulate surface textures. Bryan used the light system known as chiaroscuro, where forms are brightly lit from the front but the background reflects none of the light. It's high drama.

ARDEN HOOK, *student work. Oil on canvas, 18" × 24" (46 cm × 61 cm).*

Arden Hook orchestrated lines of various colors, widths, and directions to produce the conglomeration of bold patterns that form a backdrop for the little dog. The dog himself is constructed of a multitude of wispy linear strokes, imitating the silky texture of his coat. And in the foreground Arden used long unbroken lines to outline the sofa pillows.

MELANIE HANSBROUGH, *student work. Oil on canvas, 18" × 24" (46 cm × 61 cm).*

A strong linear statement is made in Melanie Hansbrough's still life of purple-hulled peas. Not only did she paint lines to describe the edges and surfaces of the peas, but the peas themselves are linear in shape and writhe in their multidirectional cluster. She has also used white lines of paint to highlight the peas and their copper container.

Wood Grigsby, **Level State,** *1989. Oil on canvas, 54" × 72" (137 cm × 183 cm).*

*Wood Grigsby used a vigorous linear technique to portray the young artist
Joseph Holmes, whose work also appears in this book. Here Joseph is
expressively posed in front of one of his paintings, and Wood suggested a
correlation between the artist and his work by depicting the clothing with
contrived lines similar to those in the painting. As the variety of lines whisk us
furiously in and out of the space across the top of the composition, we are
stabilized by the gravity with which Wood attaches the studio objects, as well
as Joseph and his chair, to the ground plane.*

CHRISTOPHER JOHNS, **VOLTRI FOR D. S.,** *1988. Oil on canvas, 68″ × 58″ (173 cm × 147 cm).*

Christopher Johns etched a system of lines across a painterly field of livid color to evoke great depth of space. A volumetric central shaft is surrounded by lines that graduate from thick black streaks in the foreground to spindly wisps that ramble deeper. Depth is also denoted by the illusion of the different colored lines overlapping. In another instance he has bent the angular red lines into perspective from the foreground into the distance.

LAURA GERNON, *student work. Oil on canvas, 11" × 14" (28 cm × 36 cm).*

Laura Gernon portrayed a toy dump truck with thick paint and rigorous marks, and then etched lines into the wet paint with her brush handle. Notice her structuring of red. It appears as faint pink strokes in the white of the foreground, forms thicker and more intense lines on the truck in the middle ground, and crescendos as the wall of vertical bands in the background.

DONNA MARTIN, *student work. Oil on canvas board, 14" × 18" (36 cm × 46 cm).*

Donna Martin employed line to evoke motion when she let a crazed, lipsticked monkey loose in a pick-up truck. With a rag, she exactingly rendered the soft, bulbous volumes of the truck. She then sent truck and driver speeding off with a melee of knifed, wiped, and brushed lines that dash over the contours and fly from the wheel like rushing wind.

CHARLES BARBIER, **THREE FACES OF CHARLES,**
1989. Oil on Masonite, 15⅝" × 29¼" (40 cm × 74 cm).

Charles Barbier sets in motion a profusion of both painted and etched lines in this triple self-portrait. At the left, he used the handle of his brush to delineate the portrait of himself in the past. These lines make a transition into the central figure of himself in the present, where they mingle with the painted lines of the face. Lines of raucous color compose the tribal face of Charles in the future. This mysterious self-representation reveals a hidden personal iconography but does not explain it.

DENISE PLAUCHÉ, *student work. Oil on canvas board, 16" × 12" (41 cm × 30 cm).*

Denise Plauché used hacking right-to-left strokes of relatively muted color to set up the major shapes of her composition, and then further defined them with thick lines of brighter hues applied by squeezing the tubes of color directly onto the surface. The colors of these contour lines define what space there is in this very flat painting. For example, the bright yellow lines of the hands seem closer to us than the blue lines. Denise's erratic placement of the various lines of color keeps the space alive and pulsating.

GRANT SCHEXNIDER, *student work. Oil on canvas board, 16" × 12" (41 cm × 30 cm).*

In this abstraction of the still life of toys, Grant Schexnider used a network of very regular black lines much like the lead lines in stained glass. Lines of such even width tend to appear very flat, so Grant hinted at space by using linear perspective, the changing value of the blue, and an overlapping plane. His sporadic little smears of black are a welcome diversion from the overall rigid simplicity.

PAUL CRESPO, *student work. Oil on canvas board, 14" × 10" (36 cm × 25 cm).*

My son Paul, like many artists today, was influenced by the funkier aspects of naive folk art in his linear interpretation of an old plaster carnival cowboy and a wonderful crudely crafted Mexican dog. By varying the thickness of the line considerably throughout the two figures, he has imparted an illusion of volume to a very flat motif. The lines of the checkerboard drape fall into linear perspective to distinguish ground plane from wall. It's a brash, blunt world of primary color that is pleasantly punctuated with an isolated shadow of purple stretching across the bottom.

The Landscape

There is a power in the landscape that can summon our senses into sublime meditation. Often I have found myself, eyes fixed on some panorama, mindless, bodyless, and euphoric. What can it be that entices us blissfully into submission? Is it the manifestation of space, sometimes warm and intimate, sometimes frighteningly vast? Maybe it is the exquisite, transient light, whose ebb and flow divulges all the color and form that can exist. Or is it the teeming complexity of elements, so indisputably ordered? Perhaps it is just the exhilaration of feeling part of it all. I have no doubt that all these aspects of landscape draw our attention.

And what a fertile subject for the painter: 360 degrees of unending light, color, composition, and spirituality. But the diversity can also promote frustration, so it's important that before you go tramping out into the fields, we should first examine the major elements of landscape and some ways of structuring them. I also point out that most of what will be discussed here in relation to landscape painting can be applied just as easily to any other subject you paint, just as all you have learned thus far can also be applied to landscape painting.

Light. In painting, value and color unite to produce light. In nature, light exposes vast spectrums of color intensities and value ranges as it moves through the day. In the morning, the cooler, less intense hues generally suffuse the landscape. The value range is subdued in the very early hours but expands as the light increases. As the day moves on, the cooler colors begin to warm up. Around noon, the warm colors seem to be less intense because the sun is directly overhead and illuminates forms more evenly, reducing the contrasting shadows. Color intensity and value contrasts steadily increase to full crescendo in the late afternoon, when dark, cool shadows stretch out in dramatic contrast to the hot orange light. And occasionally at dusk, when the shadows disappear, the earth becomes a dark, flat silhouette pressed against a sky of pink, orange, and red-violet from the waning sun. This breathtaking excess of nature is known as crepuscular light. I stress that these general observations are not always certain. Weather can greatly influence color and light effects. Overcast days, approaching thunderstorms, rain, sleet, and snow all present unique and challenging situations for the landscape painter.

Color. As stated, all colors exist in some form in nature, and light alters them throughout the day. All of the systems of color that you have addressed elsewhere in this book are applicable and valuable here. Once again, I implore you to seek out as much color as possible. The greatest pitfall is adhering to the blue sky/green leaves/brown trunk/red apple theory of color. Although these may be the local colors, novice painters tend to be too limited in their definitions of the various hues. For example, a tree can still be identified as green quite easily even though it was painted with greens, yellows, violets, and blues. Green would have to be only slightly dominant.

And while we're discussing green, painters agree that green can be rather difficult to compose, especially in the amount and variety presented in the landscape. Tube greens in their pure state are usually too garish for broad use in landscape painting, but can be grayed with reds, earth colors, and black, cooled with blues and violets, and warmed with yellows and oranges. Cool black and yellow will also make green. I find that the most manageable greens are those created by mixing blue and yellow. An assortment of blues and yellows in your box will provide a cornucopia of greens.

Before you begin the landscape paintings, make a chart of potential greens. It will serve as both an exercise in mixing and a future color reference. With pencil, divide a large sheet of heavy drawing paper or mat board into a checkerboard grid of at least 25 squares. Paint the squares with as many greens as you can mix, and pencil in the colors you use beside them. You'll probably tire quickly of this problem, but I promise you'll never be at a loss translating the diverse greens of the landscape.

Horizon Lines. As painters, we have two definitions for horizon line. The apparent junction of earth and sky is what we call the "visible" horizon line. The "actual" horizon line is your eye level, or the imaginary line drawn as you look straight out into space at right angles to the vertical. The two can be the same, but usually are not.

In composing the landscape you have quite a few options with regard to horizon lines. If you were to paint from a mountaintop, hill, roof, or top of a building, you would be illustrating a high actual horizon line, looking down on much of what you paint. If you sit on the ground to paint, your eye level (or actual horizon line) would be low, with most forms looming above you. Think carefully about your relationship to your subject when planning a painting, and choose an angle that will work to your advantage. The horizon lines you choose will help you organize your space, as well as provide some options for spatial dramatics. (Many of the works of Degas, for example, are remarkable for their unusual vantage point.)

Before painting, it is very important that you also consider where, on your canvas, you are going to locate your horizon line, either actual or visible. You may place it at the bottom, allowing a big sky; or at the top, producing a large foreground; or anywhere between the two. I recommend some thumbnail sketches to assess the possibilities.

Components. I have just one more request before you render a formal composition. Spend some time in the landscape sketching the various components, with drawing tools and oil on paper. I do my studies on scraps of heavy watercolor paper and discarded pieces of mat board. Special attention should be given to the many species of trees. Try to discover their peculiar shapes and simple volumes. Keep your studies lively and spontaneous. In similar manner, explore bushes, grasses, water, rocks, clouds, and buildings, or whatever else confronts you. Don't fret over how well you're painting—it's just a time for getting acquainted.

Prior to any session in the landscape, be sure to take inventory of all the equipment you may need. I meticulously visualize my painting process as I throw paraphernalia into my painting bag. There is no problem if you're painting in your backyard, but a trek into the woods requires careful preparation. Also remember that if the weather or health prevents you from painting outdoors, you can still paint the views from your windows.

Exercise: Zones of the Landscape

The most common method of structuring space is to divide it into three spatial zones: foreground, middle ground, and background. This can be suggested by your particular location—for example, a pasture located between two tree lines. Or you can simply impose your own boundaries, defining the three zones as you desire. On canvas, these are illusionistic bands, suggesting space moving into the picture plane from the bottom. Once they are in place, you can go about juggling contrasts and similarities of the basic pictorial elements of value, color, and focus. Some possibilities:

Value. You could place darker values in the foreground and background, and saturate the middle ground with lights. (This "sandwich" technique makes for dramatic contrasts.) Or paint the foreground dark and make the middle ground and background gradually lighter.

Color. You might paint greens dominating the foreground and background, with blues, yellows, and grays in the middle ground. Or you could use warm colors in the middle ground surrounded by cool hues in foreground and background.

Focus. Keep a sharp focus in the middle ground but blur it in the foreground and background.

There are legions of possibilities. For example, you might keep one element consistent throughout the zones while varying the other two. Another variation on this zonal planning is the repoussoir. This compositional device, which can be found in landscape paintings over many generations, is a foreground framing device, usually a tree that runs down one side of a canvas with its shadow spanning the bottom. Immediately behind this repoussoir, in the middle ground, would be an area of brighter, more contrasting colors. Some of the more inventive landscape painters incorporated a few lights into the repoussoir itself to echo the light behind. This was usually done with sleeping shepherds, cows, ducks, or just dappled light. In this way they kept the dark foreground frame from appearing too flat.

Pack your gear and venture outside to find a motif that might suggest the three compositional zones. Make a number of pencil sketches locating the boundaries of your three divisions. As you draw, consider how you will apply value, color, and focus to them. When you are confident of how to proceed, make a scant drawing on your canvas and start painting. Move the brush freely and directly within your organized framework. That's the reason for having one—freedom within structure.

As you work, the changing light will alter what you are observing. Don't be handicapped by this. Use the options that are parading before your eyes, fitting them into your own spatial recipe. Paint this landscape alla prima, in one session, and be aware that although you are working within structured confines, it is not altogether necessary to follow only one system too stringently. Although some abrupt transitions between the zones are desirable, more subtle ones are also necessary to draw the eye through the space more gently.

Exercise: Atmospheric Perspective

Atmospheric perspective is sometimes called aerial perspective and is literally a system of the perspective of the air. As you gaze across a landscape—especially an unobstructed deep space—distant forms seem hazy and indistinct, far less defined than the things at your feet. This is caused by distance, light, weather conditions, and the inefficiency of the human eye. Although it does not always occur naturally, this is the basis of atmospheric perspective, which artists produce by combining the pictorial elements of value, color, and focus with the knowledge that the clarity of forms diminishes as they recede into the distance.

Value contrasts should be strong in the foreground, gradually diminishing to a very close, limited range in the background. Color will modulate from very intense in the foreground to gray in the background. The edges of the forms should be hard and focused in the foreground, soft and indistinct in the background. The apparent depth of space in a painting is directly related to how drastically these elements are modulated.

Find a location where some deep space is visible. After some preliminary sketching, make a drawing on your canvas. If you've been doing this with charcoal or pencil, do it with brush and paint today, or vice versa. It helps to keep varying your approach. For clarity, I would recommend that you once again organize the space into the three zones as you did in the last problem and paint the vista adhering strictly to the recipe stated above. Try to make the intensity of the value, color, and focus diminish as evenly as possible from the foreground to the background. As you do this, ignore the boundaries you've set for the three zones.

If you wish to glimpse the other side of this system, make another painting reversing the entire process. Contrasting values, intense colors, and hard edges will now appear in the background, while their counterparts inhabit the foreground. This painting will not feel as natural, but spatial depth will still be established—almost the way it would be for a severely farsighted person who sees the distance more clearly than the foreground.

In future paintings, it may not be necessary to adjust value, color, *and* focus in order to create atmospheric perspective. Diminishing one of these elements into the distance, while the others remain intense, may render the depth of space you desire.

Exercise: Backlighting

One of the most spectacularly dramatic light events in nature is backlighting. Imagine a line of trees traversing a field, as the sun sets behind it. Cool, dark shadows are cast toward you across an otherwise pungent yellow-green field. Immediately behind the trees a hot orange sky forms a stark contrast. This is backlighting in its most theatrical form. The effect can be viewed at any time of day, depending on your position in relation to the subject and light. Any form of reflected light can also produce backlighting.

The challenge in painting backlighting lies in juxtaposing two highly contrasting value systems with virtually no transitions: a low-key system flanked by a high-key system. Seek out and paint a motif at a time of day when backlighting is undeniably present. As you render the forms that are backlit, be certain to use a variety of rich, dark colors to promote volume and movement in the somber, flat area. Paint the background in extreme high-key colors, avoiding any transitional values that may lessen the impact of contrast.

Exercise: Pattern

Value, color, shape, and line can each be patterned in painting, creating undulating forces in composition. To establish a pattern, you have only to repeat an element enough to evoke movement across the surface. Although primarily a flat concept, patterns can be coaxed into illusions of three-dimensional space. For example, consider a brushstroke repeated across a canvas. Remember from page 44 that different colors and values of the stroke will appear at different levels of space. If there are scale changes, the smaller strokes may appear farther away than the larger. And by letting the pattern of brushstrokes occasionally appear to go behind other forms portrayed in a painting, you can literally weave the pattern throughout the space.

Pattern is a common phenomenon in landscape

painting. Surely you've experienced the dappled light on the ground beneath trees, and the moving pattern of light and color on water. All kinds of objects pattern themselves—plants, tree trunks, buildings, people, even automobiles. With the slightest effort, you can find pattern.

For this painting, go out and find a pattern, or a conglomeration of patterns, that interests you. You may construct this painting as you would any other, but let the patterned element command the composition. You may wish to extract pattern from the landscape and paint a more abstract rendition. Or, as a diversion, let me suggest that you paint a microcosmic composition, using something like a small patch of grass or a tiny section of a bush or rock as your subject.

Do not make an initial drawing for this one, but block in the composition directly with turp washes. Make corrections in this stage before refining the space and pattern.

Here's a page of landscape components I sketched with brush on paper while sitting by a nearby lake on a summer morning. Many times I find myself quite satisfied filling pages with these quick little notations, never getting around to painting a formal composition on canvas.

LIBBY JOHNSON, **BIKE PATH AT DAWN,**
1989. Oil on canvas, 8" × 10"
(20 cm × 25 cm).

*My wife Libby consented to paint a
view from our yard at three times
during the day to illustrate the
changing light—a lot like Monet
painting his cathedral. This view was
done early in the morning, when the
tones were cool and restrained, with a
slightly warm sky heralding the rise of
the sun. Note that the values of the
earthbound forms move in close
progressions as you move deeper into
the painting. Atmospheric perspective
is well displayed here.*

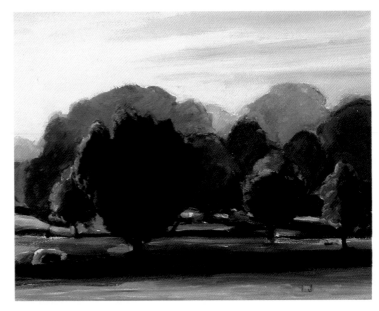

LIBBY JOHNSON, **BIKE PATH AT NOON,**
1989. Oil on canvas, 8" × 10"
(20 cm × 25 cm).

*As the day went on, Libby painted the
noon landscape, finding contrasting
shadows at the base of trees due to
the overhead light. Local color comes
more into play this time, with the
lighter, yellow-green willow trees
surrounded by the darker live oaks. At
this time of day, the sky is bleached,
almost void of color.*

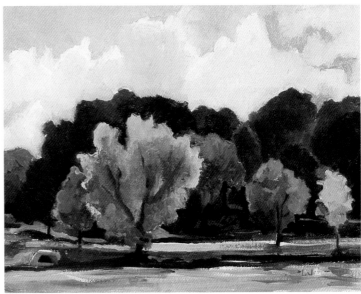

LIBBY JOHNSON, **BIKE PATH AT DUSK,**
1989. Oil on canvas, 8" × 10"
(20 cm × 25 cm).

*Dusk undoubtedly provides the most
theatrical light of the day, and we
have our share of spectacular sunsets
here in Louisiana. Libby found colors
and values at their most intense, with
hot oranges and yellows spewing from
a radiant sky, highlighting an other-
wise darkened world.*

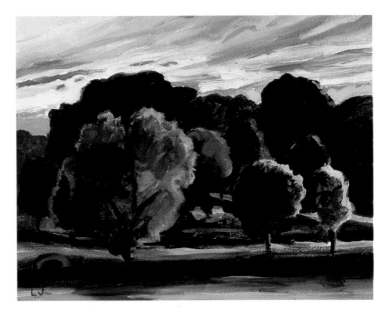

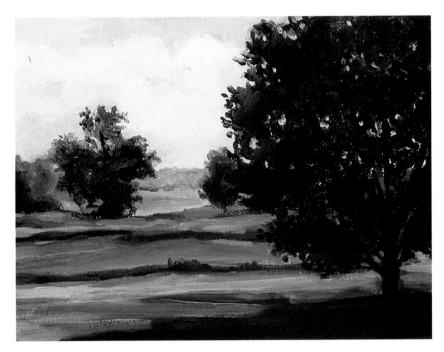

LIBBY JOHNSON, **COMPOSITION WITH TWO TREES,** *1989. Oil on canvas, 9″ × 12″ (23 cm × 30 cm).*

Here Libby painted a classic repoussoir: the large, dark tree that spans top to bottom at the right, where shadow moves across the bottom to block out the foreground plane. It's bordered by a middle ground of intense warm color striped with rows of hedge grass, ending in a tree that echoes the one in the foreground. Immediately behind it are the cool, diffused tones of the background. Libby painted very distinct zones but tied them together with a pattern of rich darks.

LIBBY JOHNSON, **BIKE PATH—7 AM,** *1987. Oil on canvas, 9″ × 12″ (23 cm × 30 cm).*

In another of Libby's paintings, the morning sun floods the interior space with the light of dawn: bluish cool near the earth, warm orange-pink in the heavens. Two blackish, meandering tree shapes with articulate edges proclaim the backlighting, together with the characteristic dark foreground. She has centered the intensity of the background light between the two trees, directly beneath the sun. This forms a powerful focus, like a marriage of the two trees with the sun officiating.

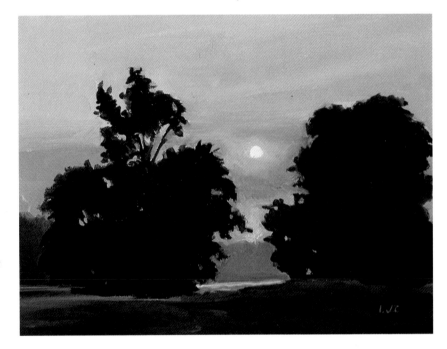

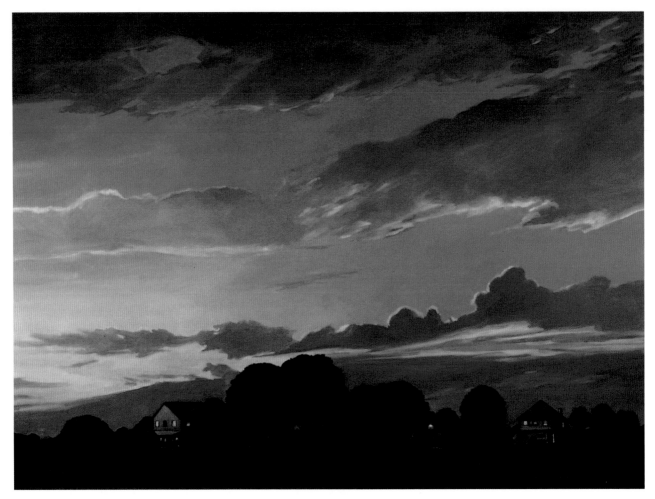

LIBBY JOHNSON, **GALVESTON HOUSES,** *1987. Oil on canvas, 36″ × 50″ (91 cm × 127 cm).*

*In this dramatic Texas landscape, Libby seized the surreal moment when the
waning sun still fosters daylight in the sky, but the earth is sheathed in
darkness. Window lights and one lone streetlight attest to this. This richly
colored light of dusk is known as crepuscular light. Libby has molded the
shadowed landscape into a triangle rising from the sides to the center of the
composition, where the pinnacle makes the strongest contrast with the yellow
hue of sunlight.*

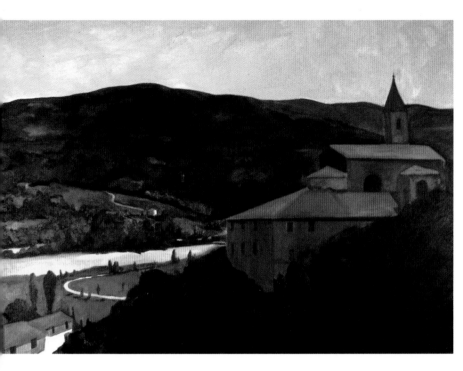

LIBBY JOHNSON, **LANDSCAPE WITH CHURCH,** *1983. Oil on Canvas, 32″ × 48″ (81 cm × 122 cm).*

Libby used the prominence of mountains to render the three distinct zones of her spatial layout. An illuminated wedge-shaped valley slices the two dark ridges that form the foreground and background. Although the large church at right center surely sits on the foreground peak, its red-orange roofs belong more to the intense light of the middle ground—a good example of form displacing content.

LIBBY JOHNSON, **VIEW FROM FORTE BELVEDERE,** *1985. Oil on paper, 5″ × 8″ (13 cm × 20 cm).*

In this small vista of the hills surrounding Florence, Italy, Libby made an abrupt but classic interpretation of aerial perspective. She skillfully painted the distant valley and hills into quasi-obscure forms, enshrouded in close-valued gray-green tones, which echo the dense greens of the foreground.

SAMUEL CORSO, **TRAIN TO PALERMO: THE SEA, MESSINA,** *1985. Oil on canvas, 32" × 45" (81 cm × 114 cm).*

Samuel Corso allowed a sheath of light to penetrate the dark waters of his Sicilian sea and form a dramatic middle ground. He looped the dark value of the foreground along the right edge of the canvas and into the background, where forceful splotches of yellow and red form isolated focal points. Sam's brush charted irregular patterns of angular shapes to portray the tumult of the water. Whitecaps traverse the entire composition, providing linkage for the three churning zones of space.

JOHN LAWRENCE, *student work. Oil on wood. 9" × 19" (23 cm × 48 cm).*

John Lawrence found pattern in the sails of boats lined up to begin a regatta. He painted the many directions of the sails in thick slabs of white, and suggested movement by surrounding them with a frenzy of squiggles and red marks. The choppy cadence of the boats is offset by the large sweeping arabesque strokes that glide across water and sky.

MIRIAM SILVEY, *student work. Oil on canvas, 24" × 36" (61 cm × 91 cm).*

Miriam Silvey submerged the coral in a sea of aqua blue, and elucidated the space with perspective, both linear and aerial. The sizes of the forms diminish as they move into the space, along a diagonal thrust. Miriam's colors and focus are distinct in the bottom and fade to the top. The result is that we are absorbed into the deep space as if slowly submerging into water.

JUANITA CACIOPPO, *student work. Oil on canvas, 11" × 14" (28 cm × 36 cm).*

Juanita Cacioppo called upon sky and water here to set apart the middle ground of land and trees. Our eyes immediately connect the soft blue tints of the foreground water with those of the sky beyond the horizon, forcing the darker grays, earth colors, and yellow-greens to cluster as a band across the center. Her rigorous brushstrokes and crusty fused edges also add a lot to this spontaneous yet structured glimpse at nature.

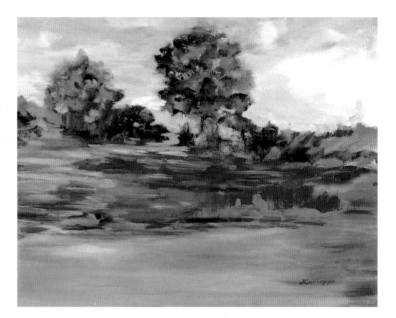

LOUISE MCGEEHEE, *student work. Oil on canvas, 12" × 12" (30 cm × 30 cm).*

Louise McGeehee reversed the role of value in this impressionistic view of a field of wildflowers. This time, value contrasts are at their most aggressive on the far horizon and very mild in the front. Although adherence to all the rules produces a more methodical interpretation of space, toying with the roles of the components can make for more intrigue and surprise.

CATALINA STANDER, *student work. Oil on canvas. 18" × 24" (46 cm × 61 cm).*

Catalina Stander's use of atmospheric perspective not only guides us deep into the space, but also suggests a morning fog in this lush tropical landscape. She has faithfully observed all the rules—diminishing value relationships, color, and focus as she paints into the distance. This can be easily traced at the bottom left, as the green yard fades to another faintly described building, through some indistinguishable forms, to gray nothingness.

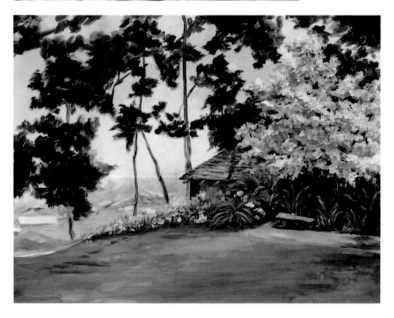

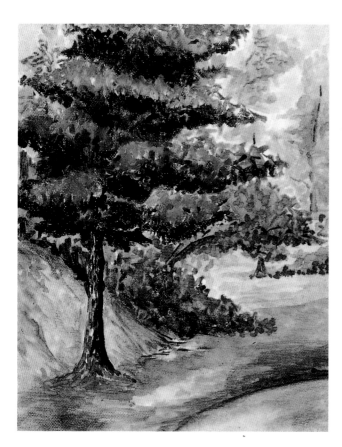

TODD PALISI, *student work. Oil on canvas board, 10″ × 8″ (25 cm × 20 cm).*

Todd Palisi not only faded the color and value as he retreated into the space, but also thinned the actual paint, going from more opaque in the foreground to turpentine washes in the background. He further unified his composition by allowing some of the wash area to remain in the bottom foreground, and by hinting at some of the foreground focus in the little spots of dark in the background.

ANDA DUBINSKIS, **LOW LYING FOG,** *1988. Oil on wood, 24″ × 39″ (61 cm × 99 cm).*

Anda Dubinskis connected three separate panels to produce this mystical narration. The curious symmetrical format aggrandizes the exquisite central tree under which the two women stroll. Paths, automobile tracks, and the two tree lines guide us into the space, while aerial perspective moves us gracefully atop the harsh linear perspective. The title's low lying fog permeates the entire composition and gently entwines all of the painting's subjects into one extraordinary reality.

CAROLINE COREY, **LANDSCAPE (MONTANA),** *1989. Oil on canvas, 22" × 30" (56 cm × 76 cm).*

In parched desert light, Caroline Corey painted a highway vanishing up to a high horizon line. Here we feel that we are viewing from a vantage point well above the desert floor. She used many temperature extremes, interlacing cools and warms throughout to intensify the blazing sense of light.

JILL COURY, *student work. Oil on canvas, 24" × 36" (61 cm × 91 cm).*

Jill Coury discovered a line of leafless trees along the bayou and exploited their similar shapes as a pattern device. She has indicated a somewhat elevated eye level by diminishing the size of the branches from right to left; their direction pushes them down and away. She emphasized the pattern with extremely contrasting darks and lights and lively, unnatural full-strength colors.

CATHY HODGES, *student work, Oil on canvas, 24" × 30" (61 cm × 76 cm).*

Cathy Hodges staged this group portrait of trees in a land of fantastic color. She used a number of diverse patterns to exercise the eye as it basks in the color sensation. Layers of multi-colored ovals, all painted in the same diagonal direction, invoke foliage. Just below, red trunks pattern their way across the horizon. And planting them all firmly in the ground is another pattern of diagonal, dark red shadows.

JOSEPH HOLMES, *student work. Oil on canvas, 30" × 40" (76 cm × 102 cm).*

Joseph Holmes has designated a large distinct shape to serve as his middle ground. It contains his primary subjects, horses and trees, but it is the preponderance of hot colors that truly distinguishes the center zone from the cool dark blues of the steam and the abrupt band of distant space that is the background. Joseph has intensified the spatial illusion with the placement of his horses. The large yellow horse in front is literally topped by the small blue and yellow one, which makes the small horse look much farther away.

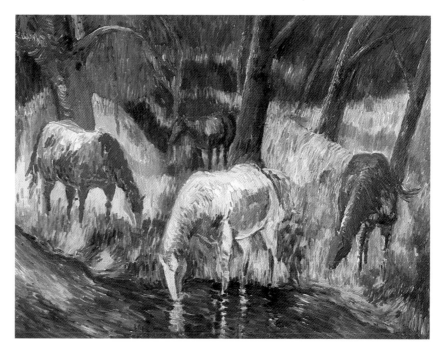

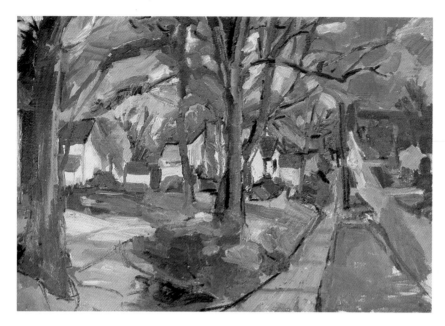

GEORGE HUNT, **NEIGHBORHOOD,** *1988. Oil on canvas, 24" × 36" (61 cm × 91 cm).*

George Hunt constructed his suburban space with an overall pattern of planes of color, supplemented and clarified with occasional lines. Ironically, he used white to form a strong focus deep in the space. As you look around his painting you can observe his process of mixing a color and applying it to different places around the canvas.

JACK KNOPP, *student work. Oil on Masonite, 18" × 30" (46 cm × 76 cm).*

Jack Knopp composed his landscape with a very low horizon line. The visible horizon line outlines the bottom of the sky, but the actual horizon is lower and out of view. The lines of the structures in the painting are vanishing to a point down and back, which means that Jack's eye level was below the ground plane in the painting. There is fine use of negative shape in the sequence of lights in the framework at the bottom.

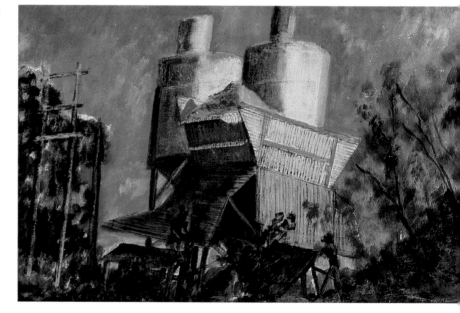

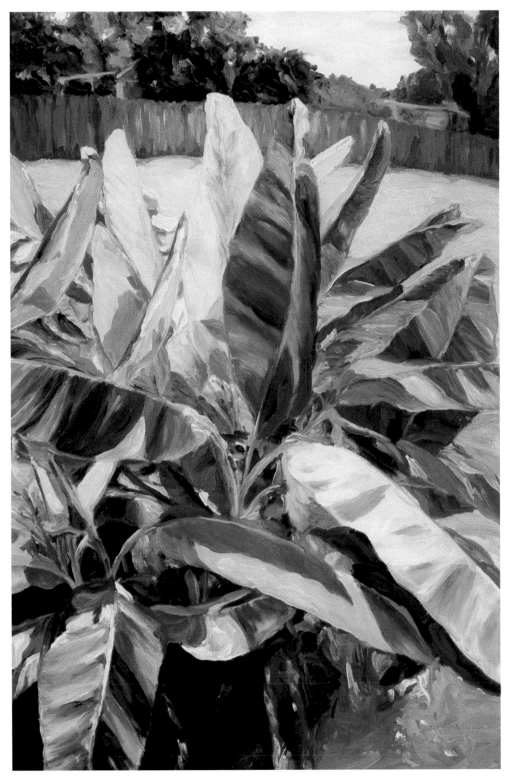

LAURE WILLIAMSON, *student work. Oil on canvas, 36" × 24" (91cm × 61cm).*

Although the foreground banana leaves shield most of Laure Williamson's painting, there is no questioning the three distinct divisions of her space. The middle ground is the flat yellow-green expanse of lawn that extends from just behind the leaves to just before the fence. Although most of its area is hidden from view, the drastic scale change from front to back and the high horizon line tell us of its relative vastness.

JOHN STRAUSS, *student work. Oil on canvas, 12" × 9" (30 cm × 23 cm).*

John Strauss selected a small area at the top of his canvas to display the full effect of backlighting—an intense eerie yellow light smack against black tree forms. The rest of the space is bathed in subdued warm light, the afterglow of the backlight. John also allowed the backlight to penetrate the rest of the space in slivers of yellow highlights that form visual steps working their way back to the distant light.

JULIE CASEMORE, *student work. Oil on canvas, 14" × 11" (36 cm × 28 cm).*

Julie Casemore used the repoussoir format to design her shimmering backlit composition. Warm, bright yellow-greens fuse between the negative spaces of the dark tree limbs, with an unexpected focus of a patch of harsh light at center left. Light also permeates the usually shadowed foreground as colorful strands of wildflowers.

MICHAEL GUIDRY, *student work, Oil on canvas, 12" × 16" (30 cm × 41 cm).*

Michael Guidry trapped light, temperature, and subject matter in the middle ground of this robust study. The foreground, with its impressive oak, shares with the background the dark reddish tones that contrast dramatically with the cool, blue-green grays of the center zone and the strong focus of light that erupts to the left of the tree. A whimsical little figure, sitting beneath a tree, further enforces the isolation of the middle ground.

ANITA MITAL, *student work. Oil on canvas, 12" × 9" (30 cm × 23 cm).*

Anita Mital painted a pine tree at arm's length and was inspired by the patterns of its unique bark. She first patterned brushstrokes of close-valued darks into troops that march up and down the vertical band. Onto these she positioned similar-size strokes of red, and finally she dispersed some shapes of yellow that were translated from light she observed on the tree.

LAURA GERNON, *student work. Oil on canvas, 12" × 9" (30 cm × 23 cm).*

Laura Gernon playfully rendered this stately tree red and found pattern in the direction of her brushstrokes that dart to and fro throughout the space like schooling minnows. With her knife, she etched lines of pattern in the tree, and their perpendicular directions helped describe the planar changes. The little white splotches to the right and left of the lower trunk enhance the stalwart symmetry of her composition.

DONNA MARTIN, *student work. Oil on canvas, 12" × 24" (30 cm × 61 cm).*

Donna Martin sat beneath one of the many huge oaks that grace the campus of Louisiana State University. A harsh afternoon sun filtered through the thick foliage. Donna left distinct negative shapes to fill the high-key colors ranging from acidic yellows to pale blues. Stray clumps of leaves and a few tubular branches break down the shapes further. With some lighter warm tones modeled into the darks she imparted a sense of the tree's heavy volume.

STANLEY SPORNY, **LIVE OAK,** *1989. Oil on canvas, 72" × 44" (183 cm × 112 cm).*

Stanley Sporny chose an urban oak to backlight in this alarming display of temperature contrasts. He laid warm and cool colors side by side throughout the composition. The back limbs are illuminated in the same jarring light that bathes the two houses, making an effective transition from the foreground to the background. Note the mysterious rainbow of colors at the base of the tree, and the way the house and awning curve as if viewed through a distorting lens. Stanley has found an exotic moment in the suburbs.

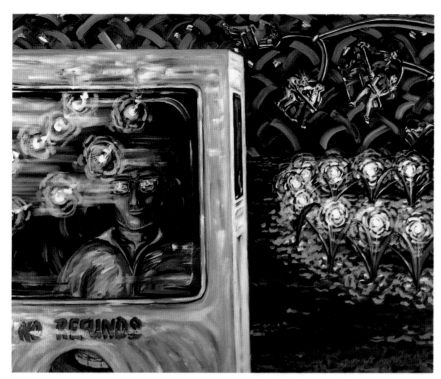

DONNA BRITT, **CARNIVAL,** *1989. Oil on canvas, 42" × 48" (107 cm × 122 cm).*

Donna Britt has coupled pattern with anxiety in this nocturnal landscape that seems to ask, "Would you buy a ticket from this man?" The artist and her husband, Mark, did. They're the largest couple, Mark in his trademark red high-top sneakers. Donna juxtaposed the wide assortment of highly agitated patterns, along with cool/warm color clashes, to identify the different zones of this humorous, unstrung delving into fear.

JIM WILSON, **UNTITLED,** *1989. Oil on paper, 24" × 36" (61 cm × 91 cm).*

In this painterly sketch for a larger work, Jim Wilson surrounded a group of descending subway riders with a myriad of patterns: the intense light as it shines through the bars of the subway entrance, the bars themselves, little dabs of light that direct us across the people, and the horizontal lines of dark windows on the sunlit side of a building. All these patterns visually compress the people on the stairs into an obscure, close-knit mass, portending their future train ride.

Indirect Painting

All possible painting methods can be simply divided into two basic techniques: direct and indirect. So far, most of the paintings you have made have been in the direct mode, or alla prima. In direct painting the artist finalizes ideas as they are painted, in one layer of paint, usually in one day. Of course the best-laid plans sometimes go awry and editing must be done in another session, usually in the form of over-painting in opaque colors to correct or enhance.

By contrast, indirect painting is a sequential process often associated with Rembrandt and the other old masters. This technique involves layering (or glazing) flat, transparent colors over a foundation of modeled values, known as a grisaille. This occurs during a number of sessions over a period of time, because the paint must be allowed to dry between layers. The method allows the artist to physically separate light from color on the canvas, and although value is visually dominant in the end, it can be seen only by peering through the gentle, jewellike veil of translucent color that lies over it. Most contemporary artists who practice the indirect method combine the two techniques, completing the indirect process with some direct painting in the final layer.

Exercise: Glazing over a Grisaille

I would like you to experience this somewhat premeditated approach to painting and initiate an indirect painting of a subject of your choosing. Paint according to the instructions in the following steps and don't rush the process. It's essential that you allow your painting to dry completely between the various stages.

Step 1. Make a light pencil sketch of your subject on the canvas, and then start to paint values, using only burnt sienna and black thinned with turpentine. You may add a little Winsor & Newton Liquin medium to the turpentine to speed the drying time. Use no white; the canvas will serve as your light. Rub back through the paint with a rag to find highlights. Make sure that your drawing is accurate, and paint as much detail as you can, even though you will have

another stage to add more. Errors are easily corrected by wiping them out. When you are satisfied with your image, let it dry completely before going on to the next step.

Step 2. Before you begin this stage, sand your painting very lightly with sandpaper of the finest grit, or a fine steel wool. (This will ensure bonding and more even dispersal of subsequent layers.) Complete your grisaille by refining it with a gray made from Payne's gray, burnt sienna, and ultramarine blue. You may now use white in your mixture for opacity. Thin the paint with a medium of one-half turpentine, one-quarter stand oil, and one-quarter damar varnish. Again, Liquin may be added to speed drying time. Do not apply any heavy deposits of paint during any stage of this painting.

Step 3. Now you are ready to glaze color over your grisaille. Remember again to sand your painting lightly. Mix your colors as you would for any other painting, and thin them with the same medium you used in Step 2. Apply them with soft brushes in uniformly thin, transparent layers. You want to be able to see the underpainting through the color. Do not use so much medium that your paint becomes runny; it's best to apply a heavier paint and thin it out over an area with your brush.

Step 4. In this final stage you should refine your color and edges by adding opaque color to the lights to draw them out, and glazing brighter transparent colors over any areas that seem a little dead. Use a slightly "fatter" medium of one-third turpentine, one-third stand oil, and one-third damar varnish. You may repeat this stage as many times as you like until every area has reached a desired color level. Your initial grisaille should now be bathed in a lucid glow of subtle color. Also note the wonderfully smooth consistency of the surface, achieved by the light sanding and the uniform application of thin color. Such a glassy surface is rarely produced by any other painting technique.

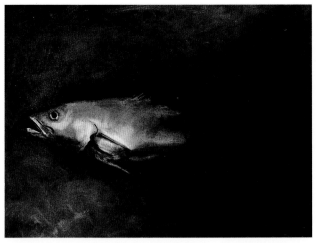

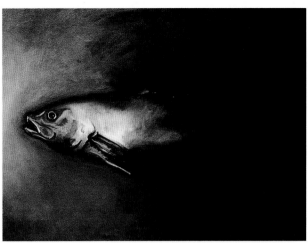

Step 1. I chose this trout, purchased from the seafood market, as my subject, but rather than paint it as a still life, I chose to portray the fish swimming into a subaqueous light. This first step of the grisaille was painted with burnt sienna and black thinned with turpentine. The soft, modeled lights of the fish were rubbed out with a cloth.

Step 2. Most of the work I did in this step was developing the fish's head. Because I desired the effect of the fish swimming out of darkness, I painted a coat of the gray mixture with no white added over the right side of the canvas. On the left, I rubbed on a light gray with a rag to produce an atmospheric light. This stage is a good time to introduce some temperature changes that can be a subtle enhancement in the final painting.

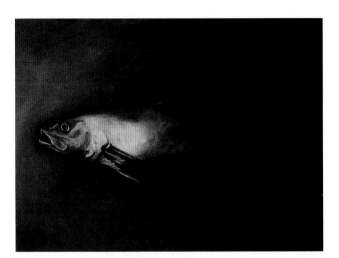

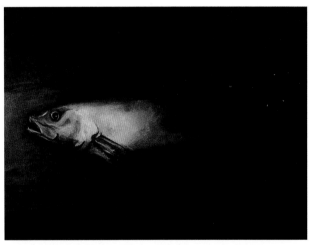

Step 3. In this stage I applied yellow, orange, blue, and violet to the fish, while brushing a uniform cadmium red over the entire background.

Step 4. At this point in my painting, I intensified the colors on the fish and toned down the background with a glaze of burnt sienna. The gestural lines that seem to indicate water movement around the fish's head were made by lightly dusting the final glaze with a rag.

Step 1. Instead of burnt sienna and black, I used Payne's gray and black for this underpainting. I used cotton swabs to rub out the highlights, and ran my brush handle down the right side of the pear to make the line of definition.

Step 2. In this step I used a gray made from Payne's gray, burnt sienna, and ultramarine blue, but pushed it to the warmer side by using more burnt umber. I carefully developed the contour of the pear and heightened the light and dark of the background. I decided to leave the etched line.

Step 3. Here I glazed some faint orange, yellow, and green tones over the pear and further darkened the surrounding area with a violet.

Step 4. I intensified the colors on the fruit, laying a red-violet on its dark side and across the bottom. The highlights were heightened by gently rubbing some white on with my finger. I darkened the background even more with a glaze of another violet.

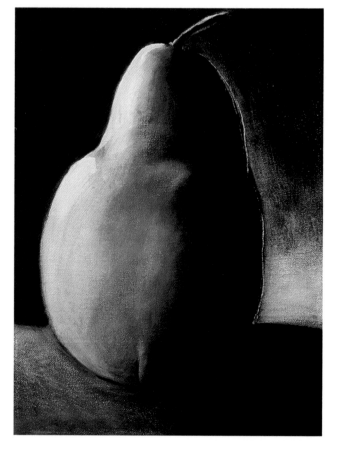

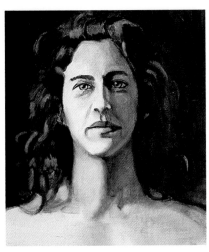

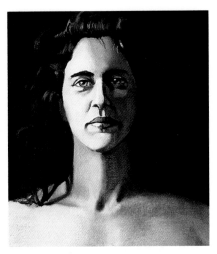

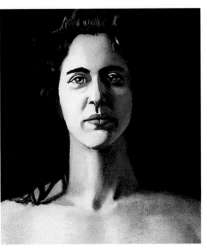

Step 1. Robert Hausey began this portrait by priming linen with rabbitskin glue and oil primer. When the primer was dry, he stained it a light brown, the color of a paper bag, using yellow ochre and burnt umber dissolved in a turpentine wash and wiped on evenly with a rag. This layer, which alters the white of the canvas, is known as an imprimatura. He then did his wash drawing using only burnt umber applied with brushes and rags.

Step 2. In this stage he finished off the drawing, introduced a temperature change, and developed a greater range of values. He used a mixture of burnt umber, Payne's gray, ultramarine blue, and white. Notice how solid the planes of the face and hair have become.

Step 3. Here Bob has applied the first layer of color in a uniformly thin, transparent layer. The colors were mixed to match those in nature just as if there was no underpainting. The warm glaze of flesh tones makes the figure spring to life in this stage. Notice the subtle glow of red behind her head at the right.

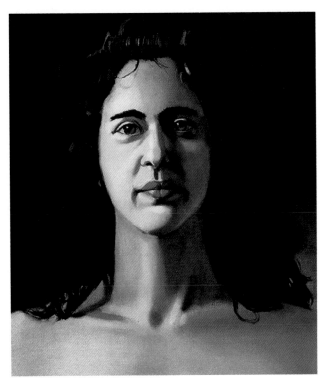

ROBERT HAUSEY, **VALERIE,** 1989. Oil on canvas, 16" × 14" (41 cm × 36 cm).

Step 4. To finish the painting Bob did more glazing with several brighter transparent colors in selected areas. For instance, a pure cadmium red was rubbed in over the right cheek. He added some opaque highlights in the face, and lightened the background over the right shoulder to provide a subtle hint of backlighting that better defines the shape of the hair.

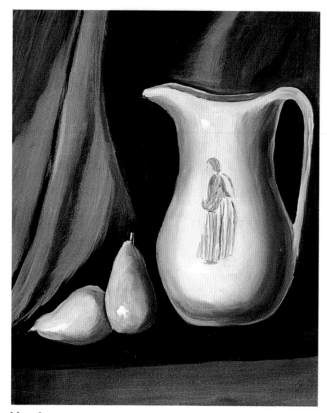

MAIA LUIKART, *student work. Oil on canvas, 20" × 16" (51 cm × 41 cm).*

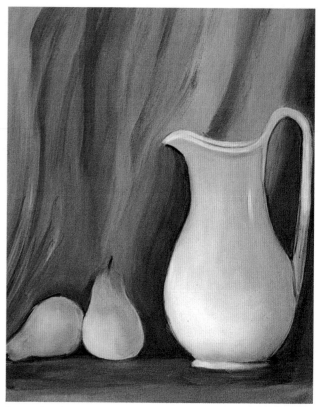

LOUISE MCGEEHEE, *student work. Oil on canvas, 18" × 14" (46 cm × 36 cm).*

Above: Maia Luikart painted this still life using the indirect process. The powerful contrast of light and dark in her underpainting establishes a very dramatic sense of light beneath the simple thin veils of color. The little decorative note on the pitcher was her final action, and the transparent pigments allow it to settle in nicely on the surface of the vessel.

Above right: In her version of the same still life, Louise McGeehee began with a subtler range of values, but very articulate drawing. She glazed blue-violet over the foreground, while mingling phthalocyanine blue with ultramarine blue in the strands of drapery folds. Quiet shades of orange, green, and yellow embellish the pears, and the pitcher is rendered with faint warm grays and a well-placed white highlight.

Right: In yet another version, Bryan Luikart explored all the nooks and crannies of the drapery folds, allowing much of his warm sienna underpainting to be seen through the glazes. This play of contrasting temperature enriches the depth of the folds and heightens the intensity of some of the blues.

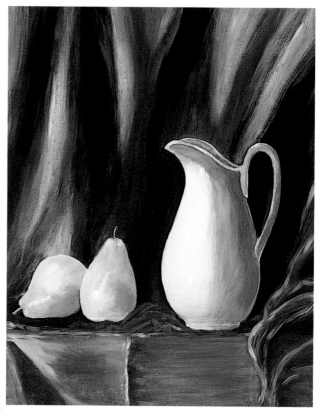

BRYAN LUIKART, *student work. Oil on canvas, 20" × 16" (46 cm × 41 cm).*

ROBERT HAUSEY, **VICTORIOUS AMOR,**
1988. Oil on canvas, 56" × 44"
(142 cm × 112 cm).

*Robert Hausey used the same
transparent glazing technique as in
Valerie (page 103) to paint this
chiaroscuro nude of classic stature.
The woman is emerging from the
background into brilliant incandescent
light, but she is still partially enve-
loped in the silky darkness. Down
the right side of her form we can just
barely identify her contour line as a
faint glow in the deep shadow. And
the leg at our left is stunningly divided
by shadow into two separate shapes.
The indirect method allowed Bob to
record the complex flood of light on
form first, before going on to color.*

LYDIA BODNAR-BALAHUTRAK, **THE
OFFERING,** *1988. Oil on canvas, 24" × 16"*
(61 cm × 41 cm).

*Lydia Bodnar-Balahutrak claims that
her paintings are conceived in and
primarily about light, so an indirect
process works well for her. She begins
with a monochromatic underpainting
of raw umber, and works from
cool colors to warm as she layers
transparencies. A wealth of color, both
opaque and transparent, is scumbled
on in the last stage, as evident in the
highly active surface. Lydia has
intensified light and color to form a
mysterious circle of light that envelops
the young girl's head and collar but
ignores all else, magnifying her
mystical meditation on the pear.*

In the Manner of . . .

The spiritual and technical essence of painting has been flowing through history for centuries, bringing vision and knowledge from the past to every new generation. And all painters absorb that aesthetic tradition, seeking what can give luster and credence to their own unique vision. The ongoing message is perpetuated in a number of ways. Teachers deliver it to their students. Artists expound its principles among themselves in both argument and agreement. The painter, alone in the studio, maneuvers its defining elements over and again with brush and paint, conducting arguments between self and canvas. And finally there are all the paintings themselves, visual pools of every technique, design, fact, and passion that has filtered through the minds and hands of artists—ours for the viewing.

I am now asking you to immerse yourself in the works of a favorite master and draw some conclusions of your own in paint. Seek out a book on a chosen painter that has an abundance of quality reproductions. Better yet, view some of the artist's work firsthand if you are in a locale where this is possible. As you study the paintings, scrutinize their elements and try to discover some tendencies and eccentricities that could constitute style. For example:

Technique. What manner of brushwork or other paint applications can you determine? What seems to be the consistency of the paint? Is the technique direct or indirect, alla prima or developed over a period of time?

Color. What color range is generally used? Intense, grayed, warm, cool? What harmonies are explored? Are certain specific hues favored?

Light. What value systems does the artist paint? Does the light seem artificial or natural, invented or observed? Are forms illuminated from one or many external sources? Or does the light seem to emanate from the forms themselves?

Composition. Where are forms generally positioned? Does the artist distort the forms? If so, how? Is the space flat, or is there illusion? Is there one focal point, or many? Is there more than one point of view?

Exercise: Painting in the Manner of a Master

In the course of a career, a painter may explore numerous modes of working. (Consider the many "periods" of Picasso.) But usually there are traits that tend to give an artist's immediate identity, whether it be van Gogh's brushwork, Caravaggio's light, Matisse's color, Morandi's bottles, and so on. I would like you to discover one or more stylistic devices of your chosen artist and introduce them into a work of your own. In other words, work in the style of another artist.

Choose any subject matter you wish: still life, landscape, interior, or abstract forms. It would be fun to try to paint something that was not necessarily the favored subject of the artist—for example, a still life in the drip style of Jackson Pollock. Regardless, paint your subject utilizing one or more of the most recognizable stylistic traits you've detected in your role model's work. As you paint, let some of your own ways mingle with those of the master. This cooperative effort should produce a unique and exciting dialogue.

Exercise: Painting a Variation on a Masterpiece

It has been a long-standing practice of artists to make variations on the great compositions of the masters, interpreting the genius found within. One has only to scan the life work of Picasso to find his many interpretations of great works by Vélazquez, Goya, Rembrandt, Rubens, and Raphael.

Choose a painting masterpiece that holds significance for you in some way. First begin by drawing from it. You then might make some quick studies in paint on paper. The idea is not to copy the painting verbatim, but to explore the composition and its elements thoroughly, imprinting your own style on to the structure you find. Make a number of variations until you find a matrix to build on or work from. Then initiate a larger painting on canvas, orchestrating your discoveries into one composition. You might consider an abstraction, or you may simply update the subject matter. It would not be unusual to develop only a thread of an idea from the original work. There are many ways to proceed. Do not be inhibited.

MICHAEL CRESPO, **VARIATION ON VERMEER,** *1965. Oil on canvas, 38" × 34"*
(97 cm × 86 cm).

As an undergraduate, I chose Vermeer's Allegory of Fame *as the object of my
scrutiny. Although I intentionally rendered loose translations of the forms, I
endeavored to keep the space intact: the tile floor design, the drape framing the
left side, the woman in the blue dress in the left center, her green headdress,
and the chandelier. I changed most of Vermeer's color to suit my more garish
tastes; where I did use his hues, I distorted their intensity to a more exuberant
pitch. As in other variations on masterworks I painted as a young student, it
was my challenge to change a lovely, quiet work into a loud, sprawling mélange.*

MICHAEL GUIDRY, *student work. Oil on canvas, 38″ × 42″ (97 cm × 107 cm).*

Michael Guidry's adoration of Picasso is revealed by his true cubist approach to this boisterous still life. Michael produced his oversized, distorted objects by superimposing a number of drawings of the still life from different points of view on one canvas. His primary colors are dramatically lit—isolated and resplendent in a murky gray field.

LAUREN CALLIHAN, *student work. Oil on canvas, 16″ × 8″ (41 cm × 20 cm).*

The elongated, dryly painted figures of Amedeo Modigliani provided the reference for Lauren Callihan's distinct still life composition. Like Modigliani, Lauren used sparse but emphatic color modeled with black. Also, her line is distinct and her cropped forms are unusually situated in an equally unusual format.

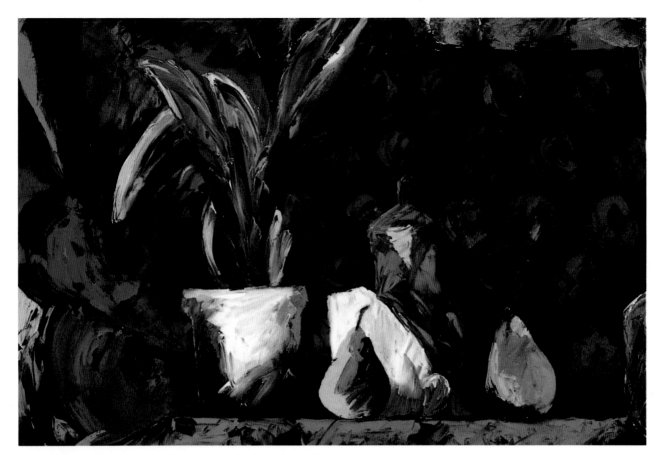

LAURA GERNON, *student work. Oil on canvas, 24″ × 36″ (61 cm × 91 cm).*

*Seeking a model for her painting, Laura Gernon researched the works of
contemporary American painter Jim Dine. She chose to emulate his chiaroscuro
light, rigorous brushwork, and spotting of lush color on a field of black. She also
found that Dine paints objects in repetition, to which she alludes in the
backdrop of patterned roses. Laura discovered a fine mentor in Dine, as her
aspirations merge well with his achievements.*

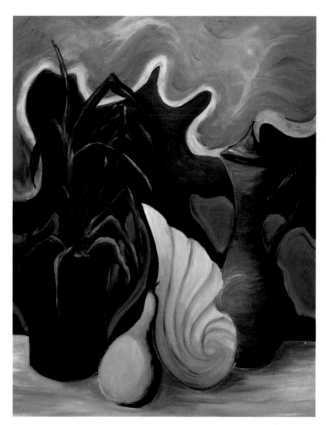

DOTTI BERRY, *student work, Oil on canvas, 30" × 24" (76 cm × 61 cm).*

Certainly the great El Greco was not heralded for his still lifes, but Dotti Berry thought him a suitable role model for hers. El Greco's great religious compositions of gnarled, exaggerated figures provided the inspiration for the serpentine line that slithers throughout Dotti's painting. Her objects are somewhat stretched and twisted, and she employs his use of primary colors and a strong light-to-dark value scheme. Dotti also discovered the master's preference for gauzy, almost transparent drapery, which she has strewn across the background.

JILL COURY, *student work. Oil on canvas, 24" × 20" (61 cm × 51 cm).*

Jill Coury observed the dictums of pointillism and the great French master Georges Seurat in her congested still life. The forms were built with little dots of different colors and values. The theory employed is that of optical mixing, in which our eyes, at a certain viewing distance, mix together adjacent colors. With pointilism we get two visual effects simultaneously—at a distance a smear of blended color, and up close the excitement of varied surface texture.

JANET JONES, *student work. Oil on canvas,
16" × 12" (41 cm × 30 cm).*

*Janet Jones borrowed from the hand
of Vincent van Gogh to paint her
nocturnal tree, a little reminiscent of
his famous* Starry Night. *Along with
impasto brushmarks, she imitated his
exaggerated color and value, and his
aggressive outlining.*

GRANT SCHEXNIDER, *student work. Oil on canvas, 21" × 20"
(53 cm × 51 cm).*

*Grant Schexnider simulated the fanatical marks of the
contemporary painter Jean-Paul Riopelle in this amazingly
conceived still life painting. The innumerable strokes of
paint, all the same size and shape, were applied with a
small-bladed palette knife. Grant made his painting in one
sitting, building his forms wet-into-wet. This caused the
mingling transitions of color and dissolution of edges that
give the work its uncanny vague presence. It's interesting
how the sharp, jagged little marks produce such softly lit
pillows of form.*

EDWARD PRAMUK, **VARIATION AND VISION: ORANGE GROUND,** *1960–1964. Oil on
canvas, 72″ × 80″ (183 cm × 203 cm).*

*For four years my friend and teacher Edward Pramuk studied in situ the great
masterpiece* Holy House of Nazareth *by Francisco de Zurbarán. The stunning,
ambitious work shown here resulted from his obsession with it. First he made a
copy of it in the museum, and then a series of drawings and watercolors that
were themes and variations, fervently distilled from the painting's color, form,
space, and complex mystical symbolism.*

*More than any of his countless variations, he writes, this painting "expresses
my feeling toward the underlying themes in the* Holy House of Nazareth, *and the
weight of my conviction toward the combination of realism, mysticism, and
abstraction. . . ."*

JOSEPH HOLMES, *student work. Diptych (right panel shown here), oil on Masonite, each panel 48" × 32" (122 cm × 81 cm).*

Joseph Holmes fused his passion for the work of Pablo Picasso with his admiration for Peter Shaffer's play Equus *in this haunting diptych. He used Picasso's early cubist style to paint the horses from multiple viewpoints, resulting in highly disjointed, distorted images. Joseph also used the limited palette of the master's analytical cubist phase.*

Both panels of this diptych contain great circular movements resting on vertical "legs" at the bottom. In the right panel, shown here, Joseph introduced an anguished human figure who stabs the eye of a horse, a thematic event in Shaffer's play.

Experiments and Explorations

From fifteenth-century paintings on armor, through the collages of Picasso and Braque, to the flamboyant constructions of present-day artists such as Elizabeth Murray and Julian Schnabel, paint has been bent, stretched, and manipulated well beyond its traditional role on canvas. Even within that realm, there are scores of materials that can be combined with oils to seek out new forms of personal expression. As artists, we attempt to craft objects of clear vision, steeped in our thoughts, opinions, and innermost feelings. The materials and techniques we employ are paramount in this endeavor.

Exercise: Working with Alternative Materials

Throughout this book we have approached image making from a number of paint and design standpoints. Now I ask you to make a painting in which you explore and experiment with some new materials or concepts. You may make a drastic departure from more standard approaches, or you may settle on a subtle deviation.

To assist, I would like to discuss some of my own work as well as that of some other artists who have sought out some personally innovative approaches to their art. Perhaps some of their methods could work for you, or at least provide an inspiration that sends you running out to the nearest hardware store or lumberyard in search of some quirky material to paint on, or with.

Open your mind. Consider the possibilities. Have a vision. Gather some materials and seek what you can find. Experiment with whatever occurs to you. And enjoy stretching the limits!

PAT CALDWELL, **EVOLUTION OF A SUNFLOWER,** *1988. Mixed media on canvas, 36" × 24" (91 cm × 61 cm).*

Pat Caldwell used collage to paint this uplifting array of pattern and texture. The great cubists Pablo Picasso and Georges Braque invented the technique of gluing various flat materials to their canvases, such as paper, cloth, and wood. Pat adhered her materials to the canvas with acrylic medium; carpenter's glue and the oil paint itself also make fine adhesives.

Pat randomly painted heavy paper and unstretched canvas with various colors. She then tore and cut shapes from them to glue down on her canvas, and finally worked back into the composition with paint and brush to establish liaisons among the various elements. The white linear marks were made with oil pastel.

ORLANDO PELLICCIA, **CANDLESTAND IMPATIENS,** *1982. Oil on cutout panel, 44" × 24" (112 cm × 61 cm).*

ORLANDO PELLICCIA, **WINDY SOCKS,** *1983. Oil on cutout panel, 28" × 96" (71 cm × 244 cm).*

Above: In another of his cutout series, Orlando Pelliccia strung an actual clothesline and attached to it painted cutouts of socks, complete with clothespins, in various windblown gestures. Precise colors and values, coupled with careful perspective drawings, bolster the illusion.

If you're considering doing a cutout, first plot your subject's overall shape on the finished side of a sheet of plywood. Cut it out with a jigsaw or router, and prime it with acrylic gesso before painting the image. Such a project should involve a lot of preparatory sketching beforehand.

Left: From a panel of wood, Orlando Pelliccia cut out a single shape that encompassed both the pot of flowers and the table. He then painted a brilliant display of light, form, and color. The piece is seen here installed in an actual space; the painting is free-standing, supported well away from the wall by a small triangle in the back. Precise placement of shadow and highlight creates a rather astonishing three-dimensional illusion. But his painterly marks, simplified form, and amplified color never allow us to be fooled for too long.

MICHAEL CRESPO, **MASSACRE OF THE RED FISH,** *1987. Oil and composition leaf on canvas, 25" × 50" (64 cm × 127 cm).*

This painting was a response to an incident in which some commercial fishing vessels tossed thousands of pounds of fish overboard off the coast of Louisiana because they had caught too much to store.

I began by priming the canvas with a coat of cadmium red acrylic paint, and then painting the images of the fish and the bird in oil. Next I laid in the leaf by painting small areas with acrylic medium, dropping in the fragile leaves, and tamping them down with cotton balls. (I do not use patent gold leaf, but composition, which is a simulation of real gold and considerably less expensive.) I left an area around the figures exposed, onto which I painted a heavy gold-colored impasto of oil paint. Finally I scratched the surface with slashing marks from a knife. All was allowed to dry for some time before I varnished the entire painting with a coat of orange shellac.

MICHAEL CRESPO, **BAD HOUSE: 4,** *1989. Oil and composition leaf on Masonite, 8″ × 12″ (20 cm × 30 cm).*

In a more recent work, a simple, strongly lit geometric form appears to float over a gold field. I started by priming a panel of Masonite with red acrylic, and then applied composition leaf to the entire surface with acrylic medium, letting gaps of red peek through. Finally I painted the gray segment over the leaf, let it dry, and varnished the entire painting with orange shellac. The panel was floated in an ash frame, which I intend as part of the painting.

MICHAEL CRESPO, **CHE VUOL DIRE, MADAMA BUTTERFLY?,** *1989. Mixed media on wood panel, 17″ × 32″ (43 cm × 81 cm).*

This diptych was inspired by Puccini's great opera Madama Butterfly. *The left panel was constructed in the same way as* Bad House: 4, *except that the geometric shape was painted using the indirect method described on page 100. On the right panel I first painted a complete portrait of Butterfly, knowing that I would eventually cover all but the eye. I then set about gluing on the strips of lead (which came from the tops of wine bottles). I warmed some areas of the lead with some orange shellac.*

MOLLY WHITE, **UNTITLED,** *1989. Mixed media on paper, 48" × 48" (122 cm × 122 cm).*

Molly White glued torn shapes of gessoed paper onto a large sheet of heavy paper to begin this rich, dark abstraction of shapes she gleaned from both her environment and her imagination. As with much of her work, she went through a process of repeated application and removal of paint until she found her composition. The paper was distressed in the process and divulges some very unique textural effects, which help visually merge the collaged shapes with the rest of the surface.

ANDA DUBINSKIS, **DUSK,** *1988. Mixed media on wood panel, 35¼" × 36½" (90 cm × 93 cm).*

Anda Dubinskis first painted the center panel of a tree of life. The golden images that flank it are symbols of evolution and were made on individual panels of wood. She mixed melted wax with damar varnish and turpentine, and built the images up from the surface by dabbing on the hot wax with a paintbrush. Later they were refined with dental tools.

 She then painted a coat of varnish onto the hardened wax images, applied gold leaf, and finished it with more varnish. She did not completely cover the top two figures of man and woman, but left the wax exposed, symbolizing the emergence of humankind.

In her diptyches, Melody always paints the two-dimensional image first, and then tries to make the sculptural zone parallel in mood what the two-dimensional is doing spatially. She says the three-dimensional zone is the soul of each of her diptyches, and it either argues with or imitates the painted half.

Above: Melody Guichet created this diptych during her pregnancy, and the images are signs of unfolding, fertility, and regeneration.

The painting on the left is straight oil on primed wood; the images on the right side are more elaborately constructed. She began them with shapes of balsa wood dipped in acrylic gel medium and stuck to the surface. She then applied the texture by mixing acrylic gel medium with zonolite, a small-grained vermiculite purchased from a building supplier. Acrylic paint was added to the wet mixture for color. The sculptural texture pours out of its format and continues along the outer edge of the frame, enveloping its mate.

Below: The pictorial narrative on the right is about heavy things wandering through space—an elephant dragging its feet through a mire, sharing its realm with a torch of sorts. On the left are forms that Melody deems familiar to elephants. She's erected more of a barrier between these components than in The Prize, which probably expresses the different psychologies of the pieces. Both are ripe in formal and narrative information from which we can weave our own interpretations.

MELODY GUICHET, **THE PRIZE,** *1987. Mixed media on panel, 10″ × 15″ (25 cm × 38 cm).*

MELODY GUICHET, **WANDERER,** *1987. Mixed media on wood, 10″ × 15″ (25 cm × 38 cm).*

Van Wade-Day recently spent a year living in Africa, and then traveled extensively in the Near and Far East. The architecture and painting of India heavily inspired her in these two works, which were made on her return to the States. She told me that they were a kind of a fictional personal history, in which she was trying to sort out the cultural confusion she had just experienced. She paints oil on primed wood, with the painted frame becoming an integral part of the piece.

In this instance, much of the architecture and some of the other shapes were cut out of a thin sheet of metal with a jeweler's saw. She buffed them with sandpaper to make a more adhesive surface, glued them onto the panel, and then applied oil paint directly onto them.

VAN WADE-DAY, **BLUE DOMED MOSQUE AMID HOUSES OF QUAINT CHARM,** *1989. Oil and metal on wood, 17" × 14" (43 cm × 36 cm).*

Much action is occurring in this little drama. The painterly atmosphere of the sky continues out onto the frame, surrounding and contrasting with the compressed mass of hard-edged shapes and patterns. Again, she has rendered much of the architecture on attached metal shapes, including the deep red shape that sprawls across the composition as a gateway to the space. Van's subtle and unusual use of materials produces the effect of an inlaid surface.

VAN WADE-DAY, **BEAUTIFUL GATEWAY TO A FAMOUS SHRINE,** *1989. Oil and metal on wood, 16" × 18" (41 cm × 46 cm).*

JAMES TEMPLER, **LANDSCAPE WITH BEACH FRAGMENTS AND PEN,** *1988. Mixed media on canvas, 40″ × 60″ (102 cm × 152 cm).*

James Templer composed this odd amalgamation of still life objects with equally eccentric technique. He glued a piece of linen canvas to a white board, and applied gesso, leaving a border of the unprimed linen. With ink and graphite he delineated the objects and sheet of music. He then painted the vast Texas landscape insert in oils and applied them stingily to the other objects, thus giving them a trace of color without surrendering their graphic quality. James enacted a wonderful little "play on media" by making the shell fragment at the top cast a painted shadow on the painting and a graphite shadow on the drawing.

You Must Remember This

Most people have difficulty perceiving the *essence* of a technique. When we are learning a new skill, too often the most important concepts are all jumbled up confusingly in our minds with a great deal of less important information.

That's why this section is here: to reiterate the key concepts presented earlier, but this time in the briefest and simplest terms. The illustrations included are meant to be the closest possible substitute for an in-person demonstration of the basic techniques of oil painting. Many of them are shown step by step.

If you forget everything else in this book, these are the ideas I want you to remember.

Color and Value Mixing

Gray can be mixed from red, yellow, and blue—but not necessarily in equal proportions, because some pigments are stronger than others.

To mix the two sets of primary grays you'll need for this painting, lay out your cadmium red, cadmium yellow, ultramarine blue, ivory black, titanium white, alizarin crimson, lemon yellow, and phthalocyanine blue.

Mix the two primary grays with a palette knife.

It's difficult to tell whether the dark color you are mixing is neutral or not, so pull a little aside and add a bit of white to determine its color. Equal amounts of red, yellow, and blue will not necessarily produce a neutral color, because their strengths vary greatly.

Now mix different values of the two grays. A little bit of turpentine added with your brush will make the paint flow more easily.

Move around the canvas as you paint. Don't get hung up on fully developing each object separately.

I paint the darkest areas in my setup as loosely defined shapes of my darkest gray, regardless of whether they fall on objects or in the spaces between them. A pattern of dark shapes emerges that will play a major role in the final composition.

I now distribute the middle grays across my painting, and will continue this process until the entire canvas is filled with shapes of value. Only then will I consider developing the objects as isolated events.

The objects begin to take form as I continue to build up the grays and blend some of them together.

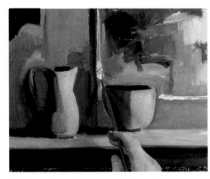

Notice how I've maintained the simple shapes of value without delving into any superfluous detail. The rectangle above the small bowl at the right is a complex view through a window, which I've represented only with irregular shapes.

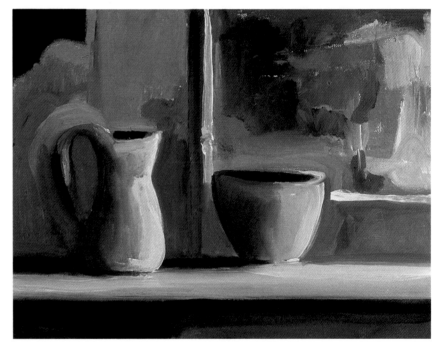

The Temperature of Color

Warm colors advance and cool colors recede.

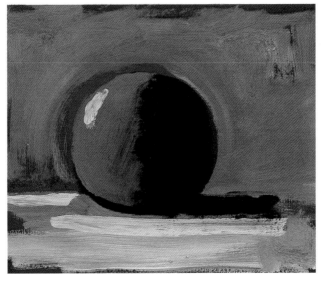

Here warm yellow and orange were scumbled over a cool blue-violet using a palette knife. The paint should be stiff enough to be manipulated with the knife. The warm colors jump forward, pushing the remaining blue-violet shapes further into the painting for a sense of depth.

In this example, a cool blue was scumbled over yelow and orange with a brush. Notice how the scumbling process allows bits of the first color to show through. Even though the cool color was laid on top of the warm, it still sinks deep in the space with the warms leaping forward.

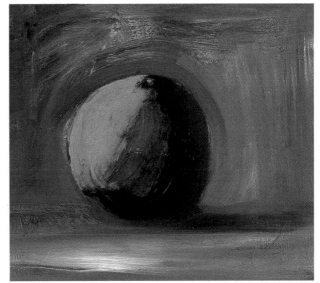

Shape

Pay close attention to the edges of your shapes. Make some of them hard and others soft.

Hard edges can be achieved by either painting one wet color alongside another, or painting over a previously painted dry color.

Masking tape can also be laid down over dry paint, painted over, and then peeled off to expose a hard, straight edge.

Hard edges can be softened by gently brushing over them with a dry brush or your finger. If the paint is stiff, dip your brush in a little turpentine.

Thin Paint

Highlights can be achieved by applying white pigment, or by rubbing back into the white of the canvas with a soft rag.

Here a highlight is being applied with a sable brush. Use a light, quick touch, and thin the paint with turpentine or medium so that it won't disturb the wet paint beneath it.

This time the highlight is being rubbed out with a clean rag moistened with turpentine. This technique does not work as well over thick layers of paint.

A cotton swab moistened with turpentine makes an ideal tool for rubbing out detailed highlights in thin paint.

Impasto

Use thick globs of paint applied with both brushes and palette knives.

Impasto paint can be applied with a palette knife, in a fashion similar to buttering toast.

Or drag it across the canvas with a brush.

The paint can also be deposited in short strokes with either knife or brush, even right on top of thick underpainting.

Interesting textures can be formed by stippling a knife in rapid motions across the wet paint. Should mistakes occur, use your knife to scrape away the globs of paint and begin again.

Modeling Form

One blending technique is to lay down dark, medium, and light values, and then smooth the transitions with a blending brush. Another is to lay down a dark color first and mix the other values on the canvas, using a blending brush loaded with white.

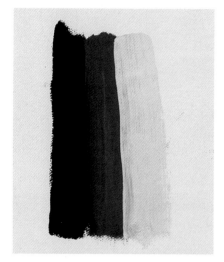
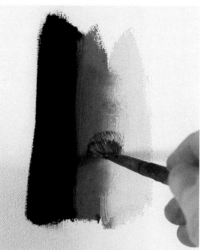

Three separate values are painted on the canvas.

They are blended together with back-and-forth motions of a dry blending brush.

A dark value of a color is brushed on the canvas.

A brushload of white paint is brushed back and forth across the shape. It may be necessary to go back in with some of the dark color if the value becomes too light.

Defining Planes

Any object, no matter how smooth or round its surface, can be broken down into planes.

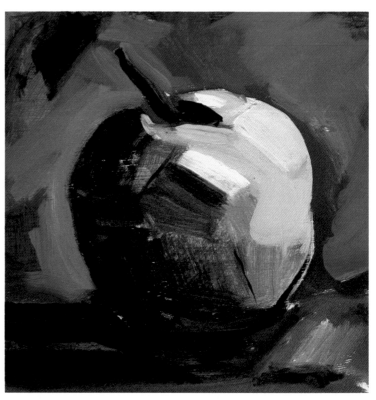

A smooth apple can be rendered in pronounced jagged planes. Remember also that warm-colored planes will advance, while the cooler ones retreat into the space.

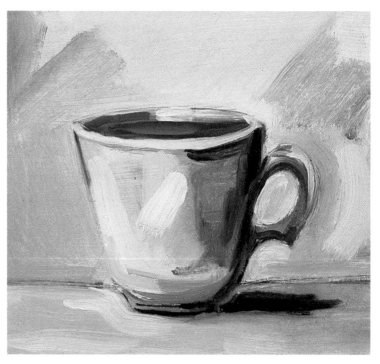

The planes in this painting of a porcelain cup were almost completely invented.

Primary Value Systems

There are three primary value systems: normal, high-key, and low-key.

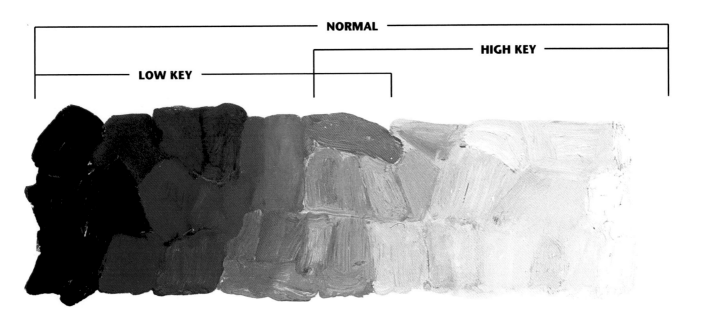

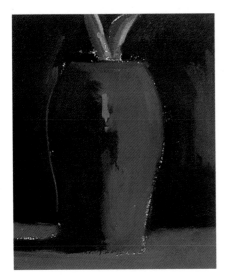

Low-key value system. The lightest light is the middle value of the normal system.

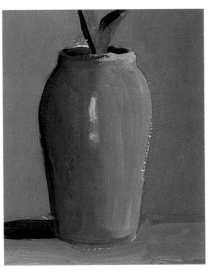

Normal value system. Dominant values are from the middle range, with extreme darks and lights used as punctuation.

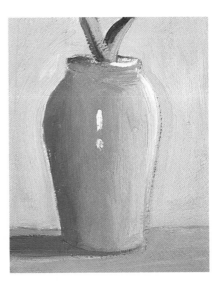

High-key value system. The darkest dark is the middle value of the normal system.

Without Brushes

There is an immeasurable supply of painting implements in your home, garden, and garbage.

A scrap of mat board or cardboard can be used to spread paint. Try putting two or more colors on the card before pulling it across your canvas.

Subtly modulating washes can be rubbed into the surface of your canvas with a rag. This is an especially useful technique for underpainting.

Dazzling textures can be achieved by loading a sponge with color and stippling with it.

Wonderful effects can be scraped into wet paint with an ordinary comb.

Color Harmony

Use your color wheel to choose color combinations that work well together. Four basic color schemes are monochromatic, analogous, complementary, and triadic.

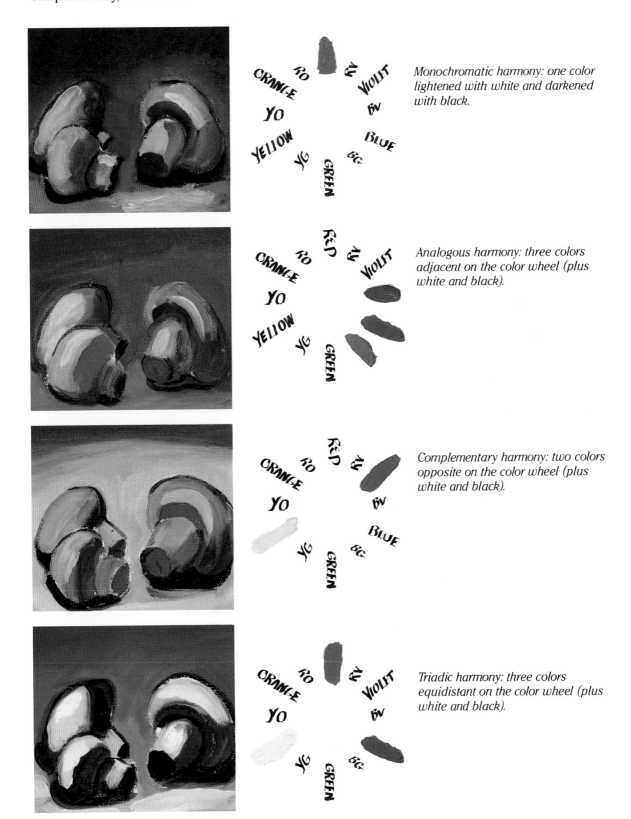

Monochromatic harmony: one color lightened with white and darkened with black.

Analogous harmony: three colors adjacent on the color wheel (plus white and black).

Complementary harmony: two colors opposite on the color wheel (plus white and black).

Triadic harmony: three colors equidistant on the color wheel (plus white and black).

The Painted Line

Vary the value, width, and color of your lines to create interesting contrasts in a painting and to evoke different emotions.

Different sizes and shapes of brushes will produce different lines. From the left, a blending brush dragged on both its flat and narrow sides; crosshatching with a #1 round synthetic; the paths of a #12 round hog-bristle, a #3 round sable, and a #12 flat camel-hair.

A palette knife can also be used to paint lines. Load its edge with paint and make a slicing motion across the surface.

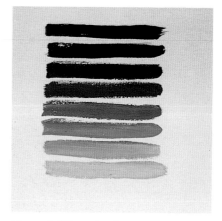

Lines of different values will appear to be at different locations in the space. Dark lines come forward, while paler lines recede.

The fluctuations in these lines were produced by varying the pressure on the brush while moving it across the canvas. Thinner lines appear to be farther back; thicker lines seem closer.

The color of a line is important because warm, intense lines appear closer than cooler ones. Also notice the varying emotional character of the various lines shown here.

Very distinct lines can also be produced by etching with a palette knife through wet paint to expose the color below. In this example the white of the canvas is exposed through a layer of black paint.

The Landscape

To paint a convincing landscape, you must establish the illusion of depth. Dividing the landscape into zones and using atmospheric perspective are two techniques that will help you achieve this.

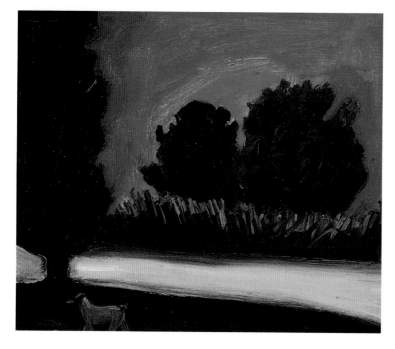

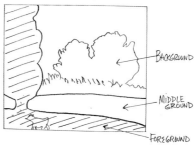

This landscape utilizes a traditional repoussoir—the dark tree at the left, and the shadowed patch of ground at the bottom. Both form the foreground. The middle ground is a contrasting plane of warm yellow-green, and the background encompasses the jagged grass, two trees, and sky. The walking dog brings a little light into the repoussoir, and helps it appear less flat.

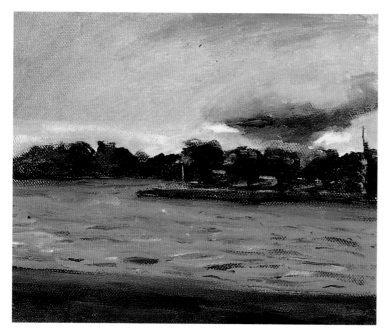

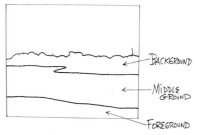

The choppy water of a lake marks the middle ground in this painting, sandwiched in by the darker gray-greens of the foreground and background. Notice the unconventional way that focus is used here: sharpening as we move toward the background.

Here is a classic example of atmospheric perspective. Intense colors, highly contrasting values, and sharply focused shapes in the foreground diminish as they move into the painting, creating a strong illusion of depth.

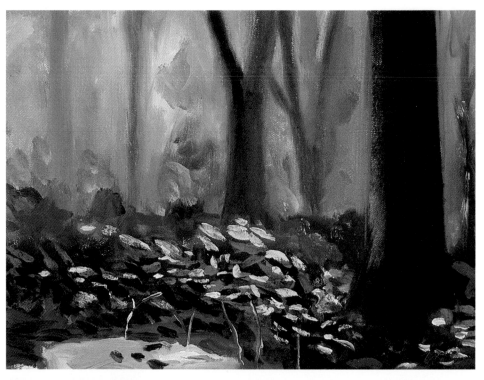

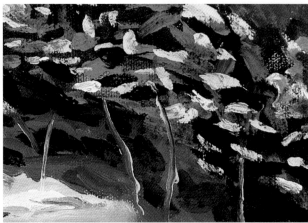

In this detail of the foreground, we see focused shapes of relatively intense yellows, greens, and blues, the values of which are either extremely dark or near white. Such aggressive contrasts tend to pull forward and dominate the viewer's attention.

In this detail of the middle ground and background, we see the colors and focus diminishing to faint grays and soft edges. Value contrasts are considerably blunted in the middle ground and almost imperceptible in the foggy distance. Such subtleties are soft on the eye and tend to move away from it.

Indirect Painting

The indirect method of painting allows you to capture light first, then color, in separate steps.

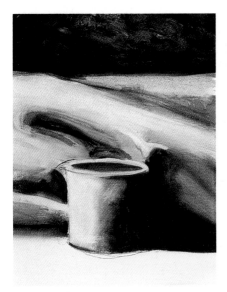

In this first stage, I used burnt sienna and black (thinned with turpentine) to develop as much detail as I could. Light areas were created by rubbing back to the white canvas with rags and cotton swabs. The texture in the dark band at the top was made by dabbing crumpled tissue into the wet color.

With a mixture of burnt sienna, ultramarine blue, and Payne's gray I made the darks more opaque and a bit cooler. Pure white was added to heighten value contrasts, which I knew would be lessened when the color was glazed over them. At this stage I thinned the paint with a medium of one-half turpentine, one-fourth stand oil, and one-fourth damar varnish.

After lightly sanding the dry painting with fine steel wool, I began to glaze color over it with a soft sable brush, using the same medium as in the last step. I stopped halfway to illustrate the "before and after" effects of glazing. Pure cadmium red was painted over the drapery, a mixed red-violet over the foreground plane, and a faint phthalocyanine blue over the cup and dark band at the top.

In the final stage I strengthened some of the red in the drapery, painted another coat of phthalocyanine blue over the dark band at the top, and added a few opaque white highlights for emphasis. In the final glazes I used the "fatter" medium of one-third turpentine, one-third stand oil, and one-third damar varnish.

In the Manner of...

Imitating a master's style is a good way to expand your repertoire of painting techniques.

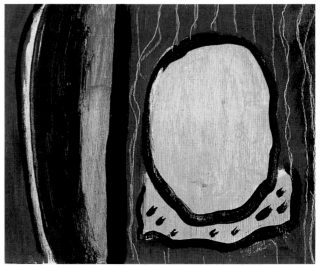

Exploring the characteristic brushstrokes of a master can lead to an understanding of how the painter rendered his subject. Here is an example of the marks of Vincent van Gogh, who painted with very deliberate strokes moving in clusters of contrasting directions, exhibiting a vast array of colors and value schemes. His famous Starry Night *will provide you with a most characteristic model.*

Here I've exploited the style of Henri Matisse, who applied his paint in brushy, thin, mostly flat shapes. Line plays a major role in his work, appearing as heavy black outline or delicate etching scraped out of wet paint.

Paul Cézanne constructed many of his paintings, such as the often-reproduced Le Chateau Noir, *with little planes of many subtle color changes, all moving in a general direction. Occasionally the planes are emphasized with a quick linear stroke. He produced a great sense of volume with the multitude of planes and their color and value changes.*

Georges Seurat invented what is now called pointilism. He painted traditional subjects by using millions of dots of different colors and values. The dots make interesting textures and mix together in the eye to form broader colors.

Experiments and Explorations

Scores of materials can be combined with traditional oil techniques to seek out new forms of personal expression.

Hundreds of materials can be glued to canvas, canvas board, Masonite, or paper to make a collage. Here I've glued down papers and fabric, and am in the process of gluing a wood strip. I use acrylic medium for light materials and carpenter's glue for heavy materials like wood.

Once the glues are dry, you can paint directly over the materials. If you wish, you can then attach light materials by using the wet paint as an adhesive.

To build up a surface on your support, try mixing such materials as zonolite, sand, or sawdust with acrylic gesso to the consistency of wet plaster. Then trowel it onto your support, moving it around until a desired texture is achieved. Canvas board, wood panel, or Masonite will hold the extra weight better than stretched canvas. Always let the gesso dry thoroughly before painting on it. Don't use your best sables for this, since brushing on a coarse surface wears out your brushes faster.

Concentrated oil paintsticks are growing in popularity. They consist of highly refined pigments bound in linseed oil and a little wax, and are much more fluid in handling than oil pastels. Paintsticks can be used on any support and will produce the linear effects of pastels, or they can be rubbed on to produce smooth transitions. Once they are applied, a brush dipped in turpentine can be used to dilute the paint into washes and produce more traditional brush effects.

One of my favorite oil techniques is making monoprints, in which a painting on glass is transferred to paper with often surprising results. Begin by making a sketch on paper, and place it under a piece of window glass. This serves as a guide for your painting. Then paint on the glass as you would on any other surface. Paint quickly to keep the paint as wet as possible.

Lay a piece of 100 percent rag paper directly on the painting; I use watercolor paper. Then print it by rubbing systematically over the entire surface with a large soupspoon.

Carefully peel the paper from the glass. An image will still remain on the glass, which can be printed again for a fainter "ghost" image, or even reworked with more paint and printed again for another monoprint.

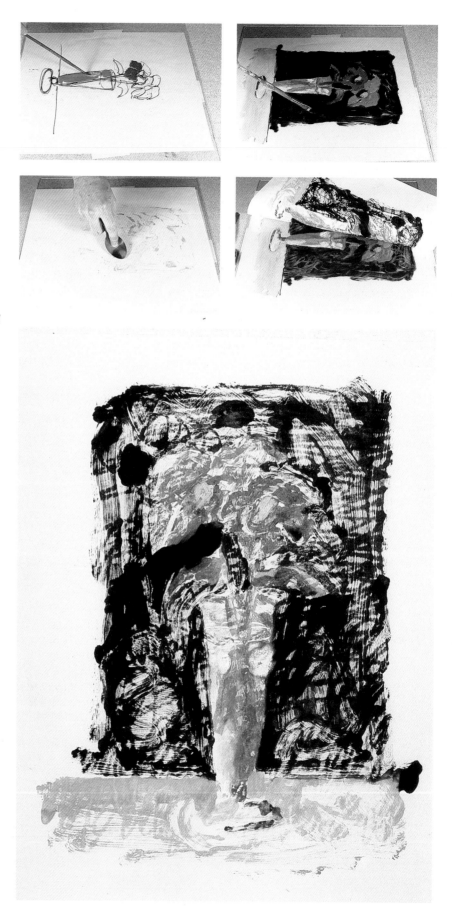

Appendix:
Stretching Your Own Canvas

You can stretch your own canvas, either primed or unprimed. (If it is raw, prime it with two coats of acrylic gesso after you have stretched it.)

Artists stretch canvas by stapling it over wooden stretcher bars, which come in pairs and are fitted together. Many sizes are available.

Most of your staples will fasten the canvas to the outside edge (not the front or back) of the stretcher bars. After stapling once in the center of one side, use the canvas pliers to stretch the canvas over the opposite side and staple once more, as illustrated. Repeat with one staple on the remaining two sides. The center of the canvas should now be stretched taut in all four directions.

Now add one or two staples to one side, an inch or so apart, gradually working out in one direction from the center toward the corner. Then repeat on the opposite side so that the canvas is pulled tight directly across the stretcher bars. Continue this, constantly rotating to the opposite side, until you've stapled all but one inch from the corner on all four sides. Be certain to pull tight with the canvas pliers for each staple.

Fold the corners over neatly, and staple them to the back of the stretcher bars. I also secure the excess canvas to the back of the bar, rather than cutting it off. Having the extra few inches will facilitate tightening or restretching your painting.

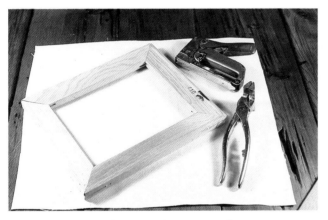

Tools you will need for stretching canvas: the canvas, a light-duty staple gun, a pair of canvas pliers, and wooden stretcher bars.

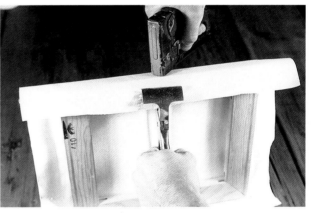

Before you insert each staple, pull the canvas taut with the canvas pliers. Keep turning the canvas to the opposite side as you add staples. This keeps the canvas stretched tight and evenly.

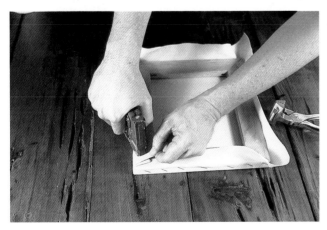

The corners are stapled last. Fasten them to the back, not the outside edge, of the stretcher bars.

Index

Alford, Lea, 52
analogous color harmony, 12, 64, 65, 66, 67, 135
atmospheric (aerial) perspective, 25, 82, 87, 89, 90, 91, 138

backlighting, 82, 96, 98
Barbier, Charles, 78
Berry, Dotti, 19, 60, 110
Bodnar-Balahutrak, Lydia, 105
Britt, Donna, 99
brushes
 blending, 38, 131
 for painting lines, 72, 136
 selecting, 8

Cacioppo, Juanita, 18, 90
Caldwell, Pat, 114, 115
Callihan, Lauren, 59, 108
canvas, 9, 143
canvas boards, 9, 28, 30
Casemore, Julie, 15, 26, 30, 35, 67, 96
Cézanne, Paul, 140
chiaroscuro, 40, 105, 109
collage, 114, 120, 141
color(s)
 harmony, 64–71, 135
 of line, 72, 136
 local, 32
 mixing, 11–15, 125–26
 in nature, 80, 97
 permanent palette, of, 10
 in spatial zones, 81, 82, 87, 88, 90, 93, 138
 temperature of, 16–21, 127
 and value, 50, 80
 wheel, 12–13
complementary color
 harmony, 12, 64, 65, 68, 71, 135
Corey, Caroline, 92
Corso, Samuel, 88
Coury, Jill, 92, 110
Crespo, Michael, 13, 29, 36, 37, 61, 62–63, 107, 118, 119
Crespo, Paul, 79
cutout art, 117

DeManuelle, Stephanie, 48
Dine, Jim, 109
diptychs, 119, 122
drawings, 9, 10, 28
dripping and pouring paint, 56, 62
Dubinskis, Anda, 91, 121

Earhart, Arlene, 31
easel, 10
edges, 128
El Greco, 110

finger painting, 56, 57, 60
Fong, Alan, 52, 59

Gernon, Laura, 24, 34, 46, 77, 97, 109
gray, mixing, 12–13, 125–26
Grigsby, Wood, 75
grisaille, glazing over, 100–105, 139
Guichet, Melody, 122
Guidry, Michael, 19, 41, 55, 69, 96, 108

Hackler, Carol, 68
Hansbrough, Melanie, 74
Harding, Ann, 27
Hausey, Robert, 43, 103, 105
high-key value system, 50, 51, 52, 53, 133
highlights, 28, 129
Hodges, Cathy, 93
Hofmann, Hans, 32
Holmes, Joseph, 36, 75, 93, 113
Hook, Arden, 74
horizon line, 80–81, 92, 94, 95
Hunt, George, 94

impasto, 32–37, 130
indirect painting, 100–105, 139

Johns, Christopher, 53, 76
Johnson, Libby, 42, 48, 54, 84–87
Jones, Janet, 30, 111

Knight, Lynette, 25, 49
Knopp, Jack, 94

landscape painting, 80–99, 137–38
Lawrence, John, 89
Leake, Elizabeth, 69
light
 in nature, 80, 84–86
 value systems and, 50–55, 80
 See also backlighting; highlights
linear technique, 72–79, 136
low-key value system, 50, 51, 55, 133
Luikart, Bryan, 73, 104
Luikart, Maia, 104

McGeehee, Louise, 90, 104
Martin, Donna, 24, 34, 40, 47, 58, 77, 97
Masonite, 9, 28
master painters, emulating, 106–13, 140
materials, alternative, 114–24, 141–42
Matisse, Henri, 140
mediums, 9, 28
Mital, Anita, 26, 30, 46, 60, 97
modeling techniques, 38–43, 131
Modigliani, Amedeo, 108
monochromatic color harmony, 64, 65, 135
monoprinting, 142

normal value system, 50, 51, 133

Opie, John, 20, 71

paint
 selecting, 8–9
 thick (impasto), 32–37, 130
 thin (washes), 28–31, 129, 134
paintsticks, 141
palette, 9
palette knives, 9, 56, 58–60, 130, 136
Palisi, Todd, 19, 40, 47, 91
Pelliccia, Orlando, 116, 117
Pharis, Karen, 73
Picasso, Pablo, 108, 113
planes, defining, 44–49, 132
Plauché, Denise, 14, 31, 35, 52, 61, 78
pointilism, 110, 140
Pramuk, Edward, 66, 112

repoussoir, 81, 85, 96, 137
Riopelle, Jean-Paul, 111
Romero, Wendy, 30, 68

Schexnider, Grant, 34, 40, 67, 79, 111
Seurat, Georges, 110, 140
shapes, 22–27, 97, 128
Silvey, Miriam, 26, 89
sketchbook, 10
Smith, Dixon, 15, 31
spatial zones, 81–82, 87, 88, 90, 91, 93, 95, 96, 137–38
Spikes, Glenda, 19, 24, 41, 55
Sporny, Stanley, 98
Stander, Catalina, 90
Strauss, John, 58, 66, 96
supplies, 8–10, 56
Sylvester, Sharon, 47

Templer, James, 124
triadic color harmony, 64, 65, 69, 70, 135

value
 of line, 72, 136
 mixing, 11–15, 125–26
 in spatial zones, 81, 82, 90, 138
 systems, 50–55, 133
van Gogh, Vincent, 111, 140
Vermeer, Jan, 107

Wade-Day, Van, 123
washes, 28–31, 129, 134
White, Michaux, 14, 69
White, Molly, 120
Williamson, Laure, 95
Wilson, Jim, 70, 99

Zurbarán, Francisco de, 112